LUNA FLORA ✿ ✿ ✿
Sculpture in Bread

Junco Hitomi

JAPAN PUBLICATIONS, INC.
San Francisco & Tokyo

Japan Publications, Inc.
Japan Publications Trading Company
1255 Howard St., San Francisco, Calif. 94103, U.S.A.
P.O. Box 5030 Tokyo International, Tokyo 101-31, Japan

LCC Card No.73-90496
ISBN 0-87040-255-2
First printing: January 1974
Printed in Japan by Toppan Printing Co., Ltd.
Design and typography by Norio Okawa

Preface

Several years ago, when I was staying in Mexico, I experienced a strong creative urge, inspired I think by the constantly blooming flowers of that southern land, the stirring remains of an ancient culture still to be seen in the Indian villages, and the emotionally moving rhythms of mariachi music.

One day when I was invited to tea in a Mexican friend's home, I was especially interested by a small ornament of artificial flowers that brightened a corner of the room where we sat. These flowers, the prototypes on which all the flowers in this book are based, were the *flor de migajon de pan,* or bread flowers, made, as I soon learned, from part of the daily meals of the family of the household. The floral ornament in the room was old, but in its simplicity it preserved an indescribable charm and gentle loveliness of color and form.

Upon returning to Japan from Mixico, I decided to attempt to use modern techniques to provide greater stability to this traditional folk craft and in this way to make these flowers something to be appreciated and loved by contemporary peoples everywhere. After devoting a great deal of effort to improving materials and systematizing the techniques, I made public the results of my work in the form of Luna Flora, the name I selected for my version of the traditional Mexican bread flowers. Although at first, the name had a decidedly unfamiliar ring in the Japanese craft world, it has by now become so familiar that anyone interested in artificial flowers knows what Luna Flora is. The novelty of the flowers and of the material from which they are made may have had something to do with the initial interest shown by some people, but I think the most important cause was the charm of the flowers themselves, their rich sense of volume, subtle expressive possibilities, interesting textures, and brilliant colors.

In this book, the Japanese-language edition of which was the first book ever published on the subject, I have included many photographs to help the individual master all the basic Luna Flora techniques and assist the teacher in instructing other people. In addition, the illustrations—especially the many color photographs—make the book beautiful to look at and attractive to own.

It is difficult to fulfill all the high hopes I have for this book, but I think my work and that of the publishers have produced a book that can be of use to people in many countries. If through this book my readers can learn the beauty and pleasure of Luna Flora and go on to develop their own flowers and other art and craft works based on the materials and techniques introduced here, I shall be very happy.

Contents

Preface
Introduction *5*
About Luna Flora *7*

Color Illustrations *9–32*

Pando *33*
Materials and Tools *34*
Production Techniques *36*
Making Luna Flora *38*
 Hydrangeas *38/* Cherry Bough *42/* Stock *45/* Lilies of
 the Valley *48/* Daisies *50/* Freesias *52/* Daffodils *54/*
 Sunflowers *56/* Rambler Roses *59/* Tulips *62/* Pansies
 64/ Geraniums *66/* Sweetpeas *68/* Roses *70/* Mexican
 Poppies *72/* Cyclamen *75/* Brooch and Earring Set *77/*
Postscript *80*

List of Illustrations

Hydrangeas and a hat ornament of stock blossoms *9*
Hydrangeas *10*
Stock *10*
Cherry boughs *10*
Mexican poppies *11*
Cyclamen *12*
Lilies of the valley *13*
Daisies *13*
Freesias *13*
Daffodils *14*
Sunflowers *14*
Rambler roses *14*
Centerpiece of fruits and leaves *15*
Tulips *16*
Geraniums *16*
Pansies *16*
Lamp base of rambler roses *17*
Sweetpeas *18*
Roses *18*
Mexican poppies *18*
Clock ornament of miniature fruits and flowers *19*

Wreath and candle stand of roses, poinsettias, and
 holly *20*
Sweetpeas and baby's breath *21*
Violets *21*
Matching brooch, ring, and earrings and a single
 brooch *22*
Hat ornament and a brooch of roses *23*
Brooch, ring, and earrings of roses *23*
Bouquet of roses and baby's breath *24*
Orchid corsage and small bouquet of sweetpeas *24*
Hat ornament of anemones *25*
Pink roses *26*
Red roses *27*
Tulips and daffodils *27*
Lamp base of carnations *28*
Bouquet and hair ornament of white roses and
 baby's breath *29*
Persimmons and fall foliage *29*
Anemones *30*
Double stock *30*
Wall ornament of fruits and leaves *31*
Gladiolus *32*

Introduction

Origins of Luna Flora

The origins of Luna Flora are to be found in the *flor de migajon de pan* made by the peoples of the Latin American countries and especially by the Mexicans. In these nations, elderly women knead the soft, white part of bread into a plastic substance from which they fashion small flowers and ornaments that are put in the sun to dry. But this craft is fundamentally no more than a pastime. The crude materials—some bread and a small amount of adhesive—permit neither extensive manipulation nor sophisticated expression. With the traditional Latin American material it is difficult to produce anything worthy of the name of art.

Although it is true that I have taken a hint from the *flor de migajon de pan*, I have gone well beyond the old tradition in that I have created new, more refined techniques and methods. Developing these things caused me great labor and mental suffering, but they are now the source of great pride.

New Materials

The birth of Luna Flora, then, came about as a consequence of my admiration for the idea of making ornaments and flowers from bread and my determination to raise this pastime to the level of a true art. The first step in this process was obviously the production of a suitable basic material that would enable me to express creative ideas and individuality. The material I was seeking had to fulfill the following requirements: (1) be capable of long-term storage, (2) be easy to work into fine, detailed forms, (3) be capable of being colored at any stage in the creative process, (4) be mass produceable. Satisfying all these requirements proved very difficult.

Using bread and vinyl adhesive as a base and adding preservatives, I made many different test batches, but each had its drawbacks. Some were difficult to color, some spoiled rapidly, others refused to lend themselves to detail work. Finally, I succeeded in producing a material that fulfilled the first three requirements, but mass production remained beyond my capabilities. For this, I had to rely on the research and efforts of a specialist.

Taking all the data I acquired in private experiments and including some sample batches of my test materials, I called on a large Japanese flour milling company. They agreed to perform some research on my

project, and I opened the Junco Flora School, where my pupils and I tested the materials sent by the milling company. Finally we obtained a material I thought was exactly right. I named that material Pando, and now it is used all over Japan in making Luna Flora.

Once Pando had been perfected, I was on the road to developing a simple folk amusement into a full-scale, high-level craft capable of growth into an art. Realizing how far Pando was from the crude bread materials of Latin American tradition and seeing that I now had a completely new kind of craft ready for experimentation, I was deeply moved and very happy. The name Luna Flora, or flower of the moon goddess, was selected as an expression of my joy at this knowledge. (Throughout this book, the word Pando is used for the material from which Luna Flora are made. The commercially made, mass-produced Pando sold in Japan is of ideal quality. Following the directions on p 33, you can make your own Pando at home and achieve something like the effect that you could with the commercially manufactured material, though, because of differences in mixing and kneading techniques, the two substances are not identical. Anyone who would like to obtain some of the Japanese product should get in contact with the company named in the back of the book.)

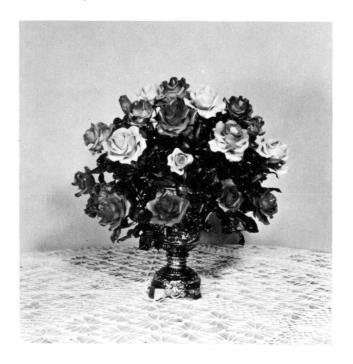

About Luna Flora

Characteristics

Before beginning the explanations of materials and methods used in creating Luna Flora, I should like to take the opportunity to explain how these flowers differ from all other art flowers by listing their characteristics.

1. When they are dried, flowers made from the Luna Flora material called Pando are as hard as porcelain, though they have a certain pliability. They have a sense of mass and volume and are extremely durable.

2. Oil paints used to produce colors in Luna Flora ensure rich, brilliant colors that neither fade nor change.

3. The smooth, close grain of the surface of Luna Flora materials makes possible reproduction of subtly detailed forms.

4. Because Luna Flora are truly handmade, each flower and bouquet is original in the sense that there is no other like it in the world.

General Production Comments

1. Give full reign to your own creative abilities and sense of color and form. The possibilities of Pando provide you with an unlimited range of opportunities to express yourself in flowers. Throughout this book, basic techniques and ideas will be presented. Until you have mastered them, it is best to adhere to the advice given in these pages. Once you have advanced beyond the beginning step, however, do not limit yourself to realistic representations. Allow your eyes and your fingers to work together to create completely new flower forms.

2. The heart of Luna Flora is the spirit of nature. Instead of relying on patterns and ready-made molds to produce flower shapes, use your own fingers to a maximum extent. Of course, a minimum of basic tools is required.

3. Oil paints best suit the nature of Pando. Vary intensity and darkness to suit the work in hand, but never allow colors to become so thick and overpowering that they destroy the characteristic quality of the material.

4. Remember that rounded forms—perfect spheres, oval spheres, and drop shapes—are the fundamentals of all Luna Flora. Train your fingers to be able to produce multidimensional shapes from these forms.

5. Because it can either accentuate or completely destroy the beauty of the flowers, the container in which they are displayed is of the

greatest importance. Select vases carefully, and remember that the best containers are not always the most expensive ones. Generally the best vases are moderately quiet containers that remain subordinate to the flowers.

From these general remarks, you can see that Luna Flora have certain appealing points not found in other floral arts and crafts. What you make is entirely a matter of your own tastes and creative talents. Luna Flora techniques lend themselves to the creation of all kinds of plants, including showy roses, more humble flowers and grasses, ornamental leafy plants, and even fruits. Furthermore, Luna Flora have an almost unlimited range of decorative uses. They make attractive buttons and jewelry. They can be combined to form wall ornaments, bridal bouquets, corsages, and similar decoration. But their distinctive beauty and richness perhaps find most striking fulfillment in large decorations for the centers of dining or party tables.

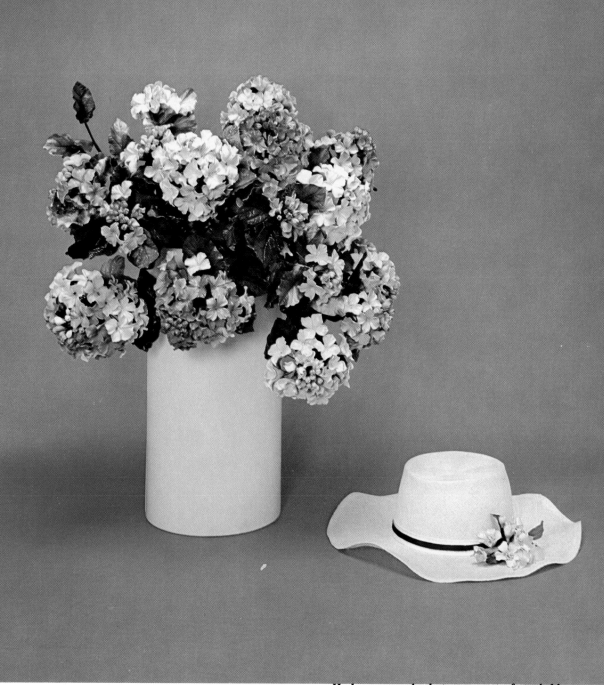

Hydrangeas and a hat ornament of stock blossoms.

The white, rose, and green blossoms seem to
suggest someone just embarking on a trip
that may bring great happiness.

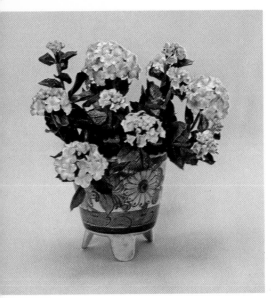

Hydrangeas (see p. 38).

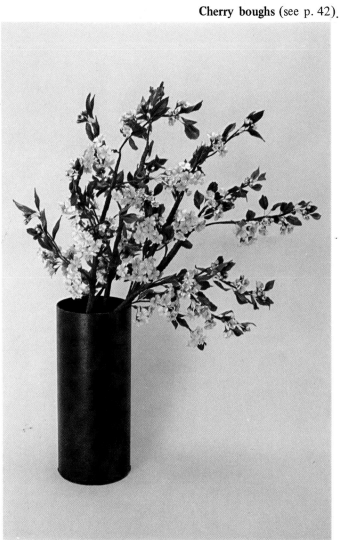

Cherry boughs (see p. 42).

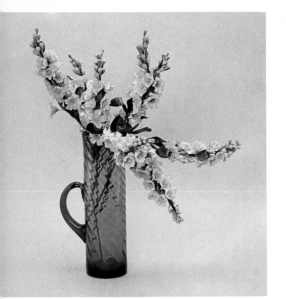

Stock (see p. 45).

The rich colors of the heavy flowers
create a calm, reflective, yet sunny
atmosphere.

Mexican poppies.

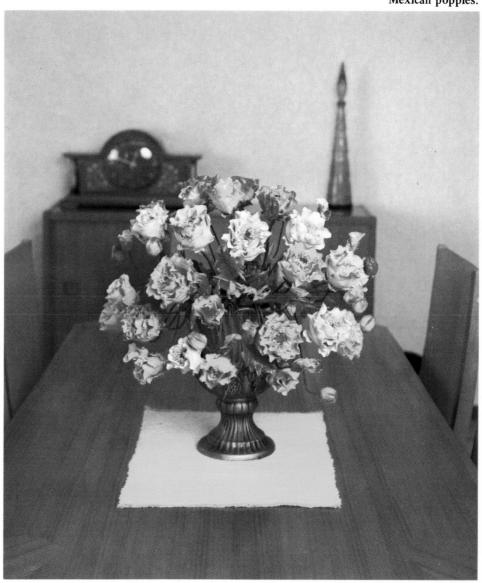

Cyclamen (see p. 75).

The delicate flowers seem to reach
outward for the soft spring sun.

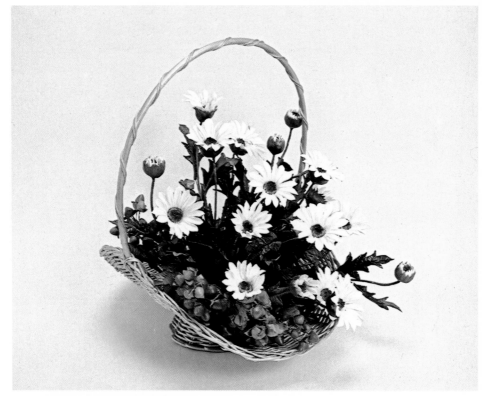

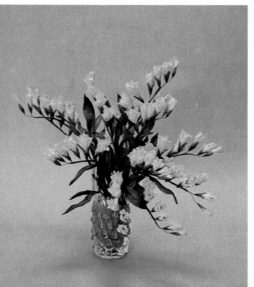

(top) **Lilies of the valley** (see p. 48).
(middle) **Daisies** (see p. 50).
(bottom) **Freesias** (see p. 52).

13

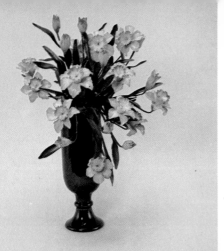

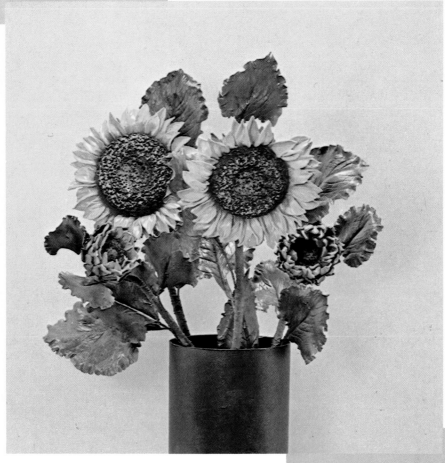

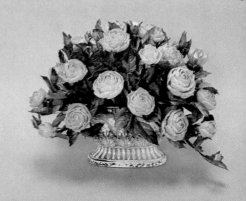

(top) **Daffodils** (see p. 54).
(middle) **Sunflowers** (see p. 56).
(bottom) **Rambler roses** (see p. 59).

14

Centerpiece of fruits and leaves.

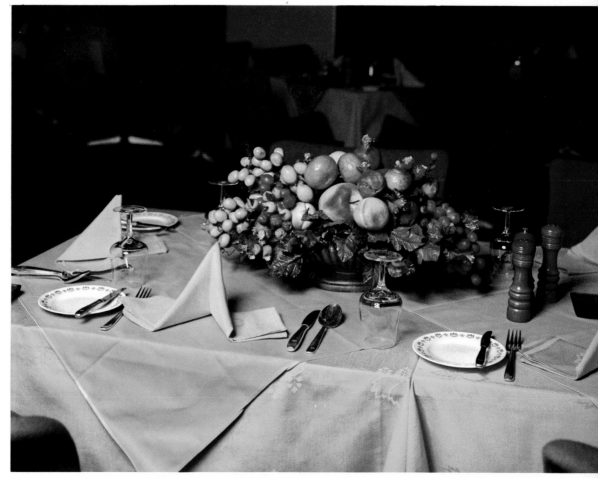

The rich tone of grapes, apples, and other fruits piled in a deep bowl promote dining elegant. Smaller centerpieces of a similar nature would be a welcome addition to an intimate family table.

(above) **Tulips** (see p. 62).
(top right) **Geraniums** (see p. 66).
(bottom right) **Pansies** (see p. 64).

16

Refined bronze tones in a gracefully shaped
mass of roses top an urn that has something of
the dignity of ancient Greek designs. Roses and
urn combine to make a handsome lamp base.

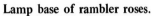

Lamp base of rambler roses.

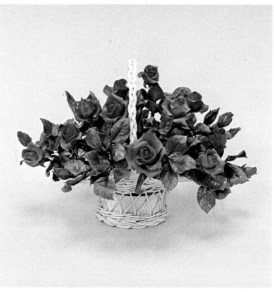

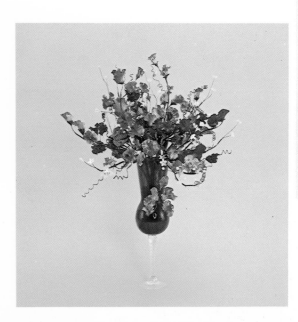

(left) **Sweetpeas** (see p. 68).
(above) **Roses** (see p. 70).

Mexican poppies (see p. 72).

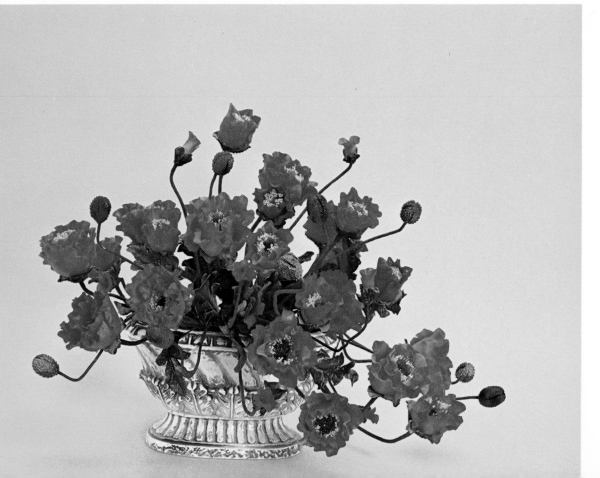

Fanciful berries, fruits, and blossoms soften
the severity of the clock face and make it a
pleasure to watch time go by.

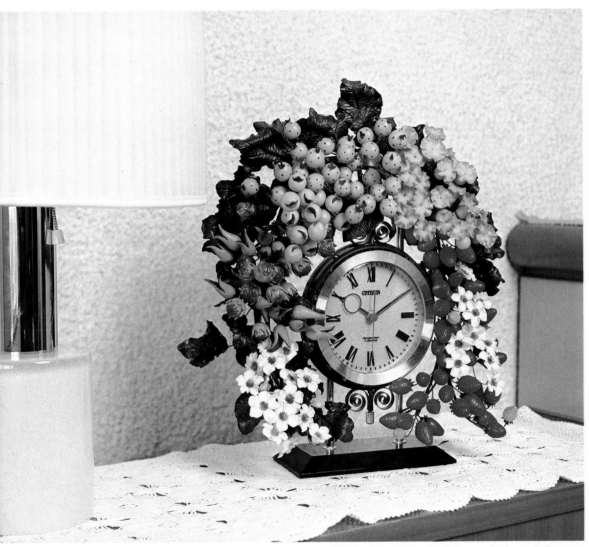

Clock ornament of miniature fruits and flowers.

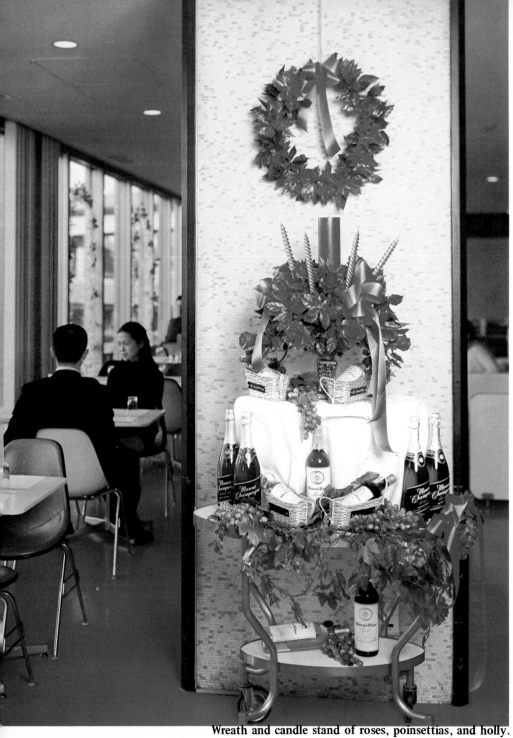

Wreath and candle stand of roses, poinsettias, and holly.

Bold colors and forms enhance the appeal of
these Christmas decorations.

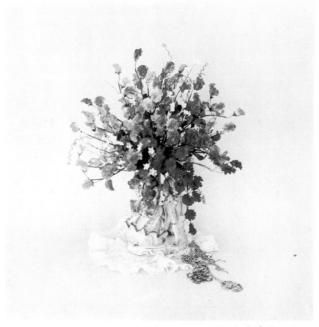

Two arrangements with the simple, fresh appeal of birdsong on a cool morning.

Sweetpeas and baby's-breath.

Violets.

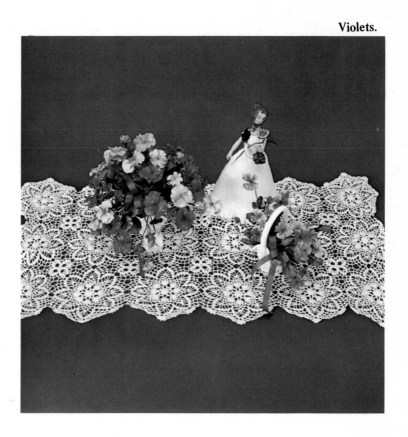

With Luna Flora you can make just the right piece to
add a distinctive, personalized look to your clothes.

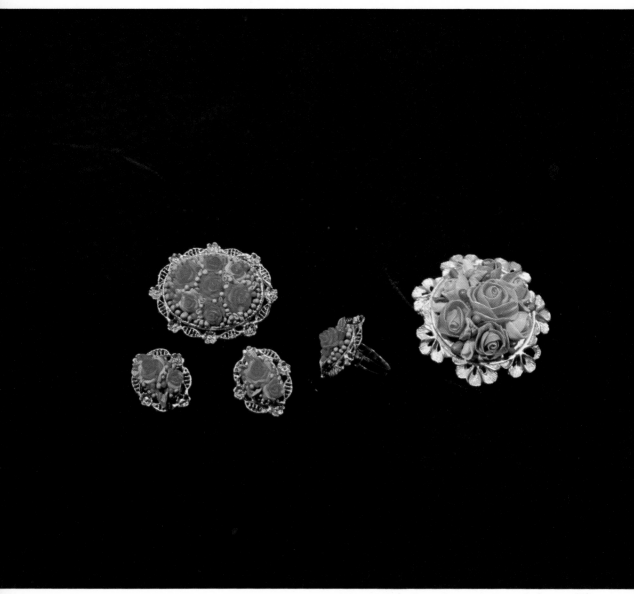

Matching brooch, ring, and earrings and a single brooch (see p. 78).

Costume jewelry on
the rose theme pro-
vides the perfect
accent.

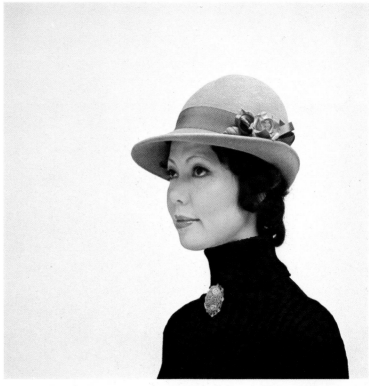

(above) **Hat ornament
and a brooch of roses.**

(left) **Brooch, ring, and
earring of roses.**

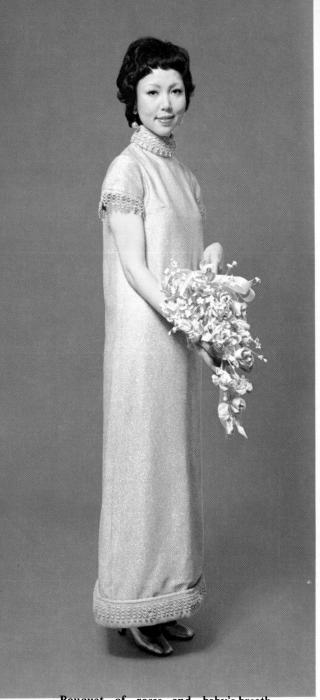

Bouquet of roses and baby's-breath.

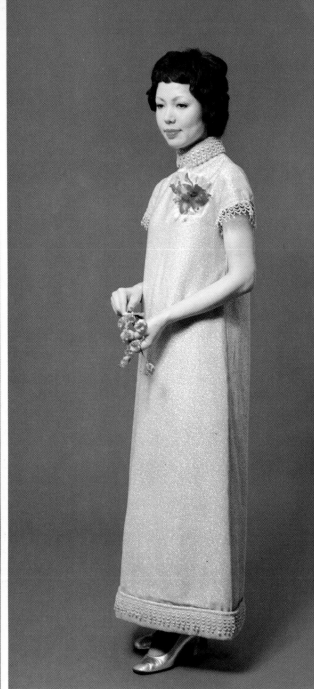

Orchid corsage and small bouquet of sweetpeas.

Bridal bouquet—flowers of happiness for the brightest day in a woman's life.

An orchid corsage for that very special dress-up occasion.

What makes a woman know she looks her best?
A stylish hat with the right floral touch.

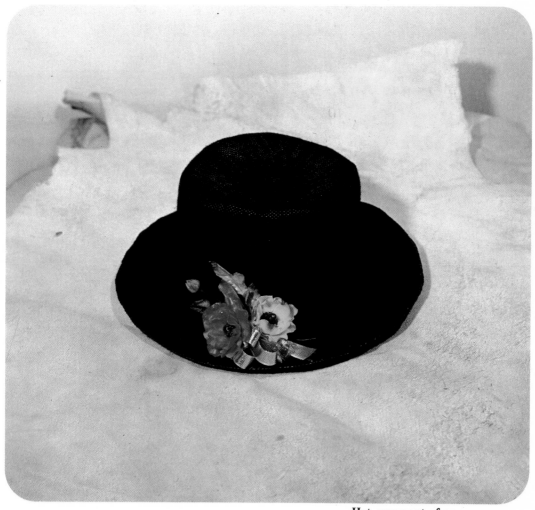

Hat ornament of anemones.

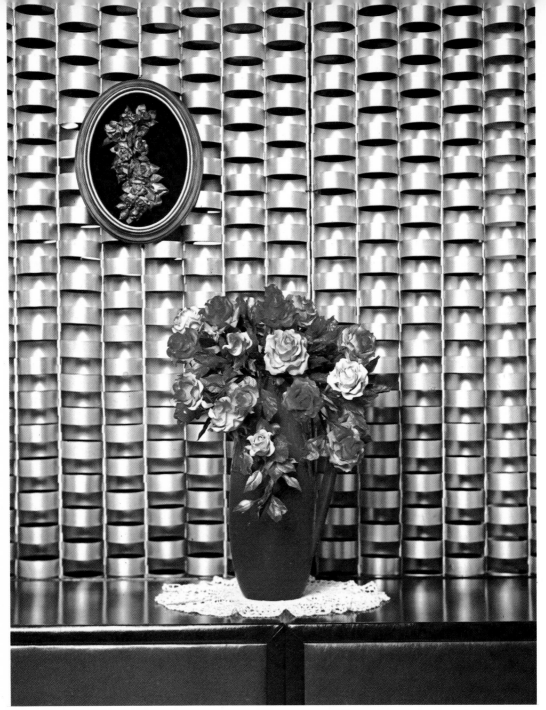

Pink roses.

For these roses—lovely enough for a knight to present to his lady—select a quiet corner of a room.

Roses in exotic colors that breathe the passion of southern lands.

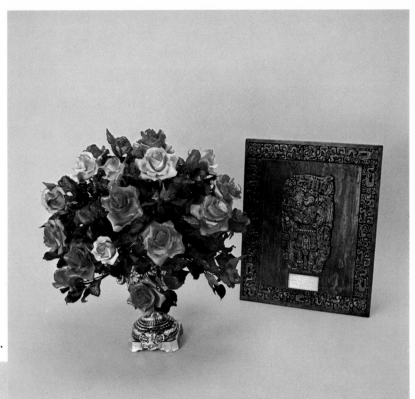

(right) **Red roses.**

(left) **Tulips and daffodils.**

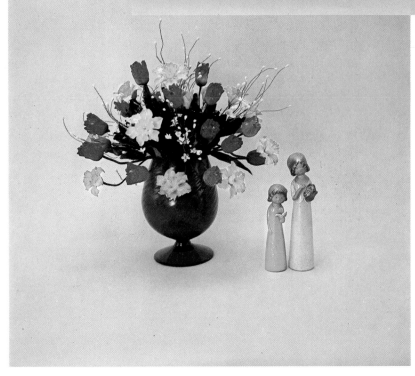

A floral cocktail of tulips and daffodils.

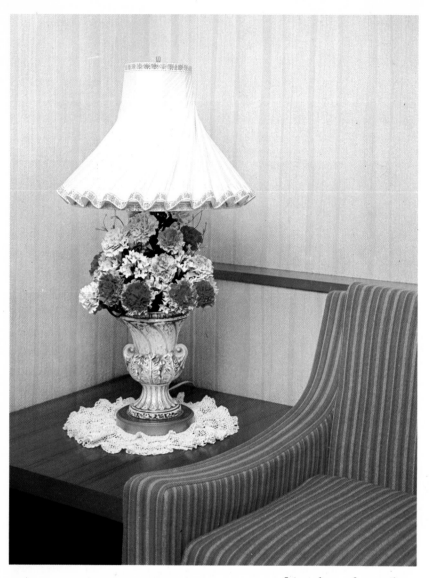

Lamp base of carnations.

Pink blossoms for a note of Parisian
elegance.

Though the arrangement of wild grapes, persimmons, and leafy branches is based on a Japanese autumnal theme, it matches the mood of any room perfectly.

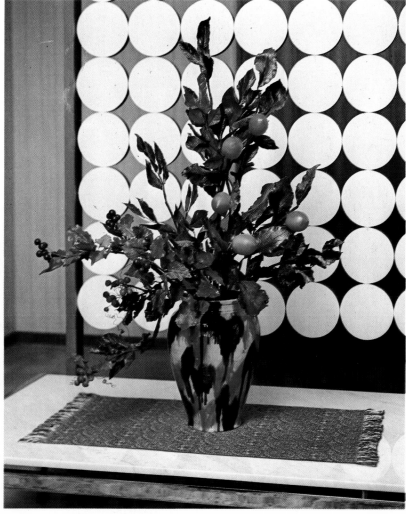

(above) **Persimmons and fall foliage.**
(left) **Bouquet and hair ornament of white roses and baby's-breath.**

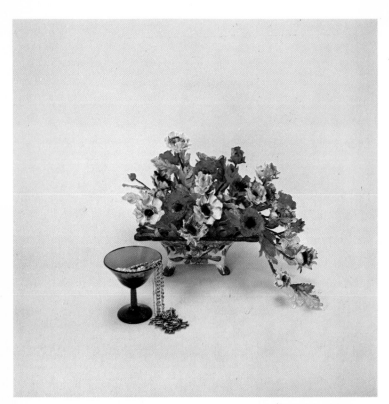

Anemones to bring back
sweet memories after the ball
has ended.

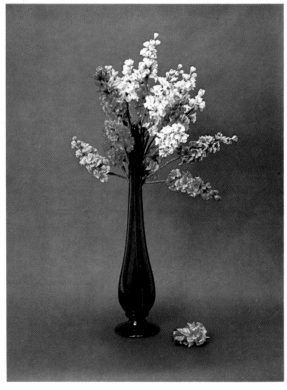

And old-fashioned flower in
new-fashioned colors.

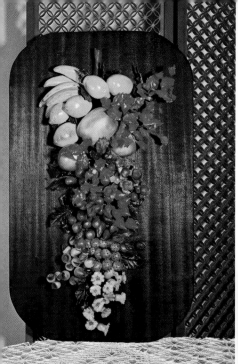

Rich in color, rich in associations—a stunning wall ornament of intensely colored fruits and leaves.

(above and right) **Wall ornament of fruits and leaves.**

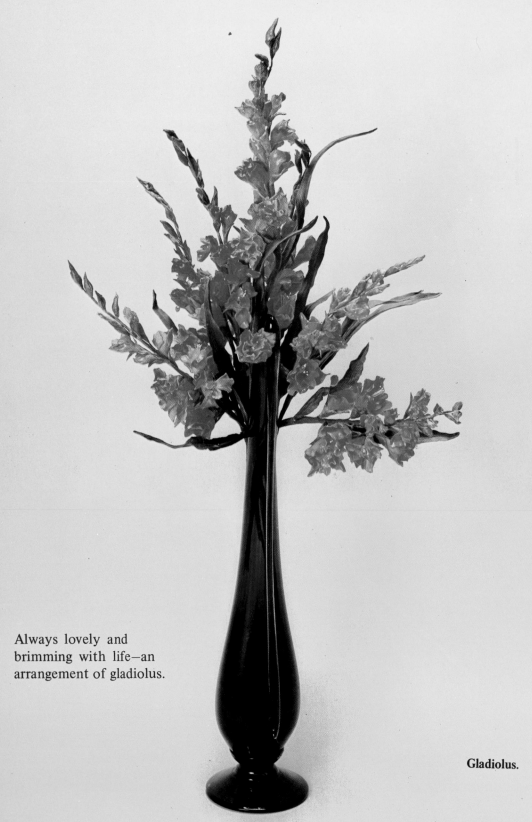

Always lovely and
brimming with life—an
arrangement of gladiolus.

Gladiolus.

32

Pando

The basic beauty of Luna Flora derives from the nature of the material from which the flowers are made. Research has made possible the mass production of a stabilized Luna Flora material called Pando; but should you live in a part of the world where this material is unavailable, you can make your own Luna Flora material following the directions given below.

Homemade Pando

Because of the nature of commercial mixing and kneading processes, the mass-produced material is guaranteed to be of ideal quality. It is difficult to produce a completely satisfactory substitute in the home. Still reasonably good results can be obtained, and if you apply your own ingenuity to the problem, you may be able to improve on the method explained here.

MATERIALS
 Bread: one pound
 Vinyl adhesive agent: 150cc
 Cornstarch: one tablespoon
 Hand cream: small amount

PREPARATION
Remove the crusts from the bread; you will use only the white part. Tear the bread into fine crumbs. In a large mixing bowl, combine the bread and the other ingredients (Photograph 1). Mix them well (Photograph 2). Then knead the doughlike mixture for about thirty minutes or until a smooth, homogeneous, elastic mass forms (see the photograph on p. 35).

NOTE
In hot, humid regions, homemade Pando may mold or otherwise spoil. Prevent this by adding a food preservative to the ingredients before mixing. This danger has been completely eliminated in commercial Pando.

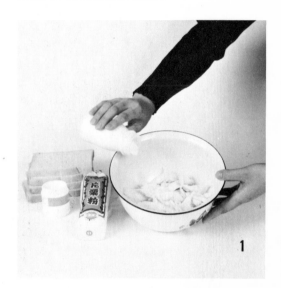

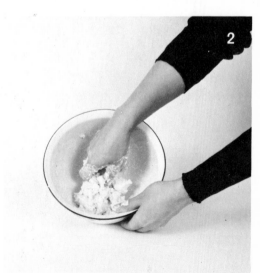

Materials and Tools

The following list includes the materials and tools used in this book. Not all of these things are absolutely essential, but they are convenient. Use your imagination to substitute for the tools that are unavailable where you live. (The letters in parentheses correspond to the letters below the materials and equipment in the photograph).

Materials

Pando. The major material of Luna Flora is the distinctive bread-based Pando, which allows extremely delicate, thin forms that are nonetheless strong. Coloring may be achieved by one or both of two methods. Oil paints may be kneaded into the Pando while it is still soft, or the finished work may be colored with brush and paint. Pando requires about three days from complete drying (C).

Wire. Suiting the size to the needs of the flowers or leaves being made, use wires in the range extending from size number 14 to number 26. The wire used in this book comes in a standard length of 36 centimeters or 16 inches (G and H).

Floral tape. Floral tape in a variety of colors is used to wrap the wire stems and to attach leaves and flowers to branches (F).

Styrofoam. The kind of styrofoam used in packing and insulation is very handy for Luna Flora: it can be used to form the centers of large flowers like the sunflower or the cores

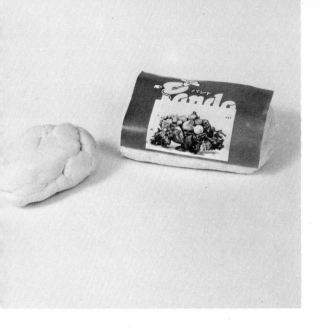

Pando: homemade *(left)* **and commercially manufactured** *(right).*

on which to build fruit shapes. In addition, it is convenient as a base for floral arrangements (E).

Tissue paper. This is used to pad stems in order to increase their variety and to make them more natural in appearance (D).

Adhesive agent. Vinyl adhesives are recommended. They are used in attaching leaves and flowers to wire and in fixing floral tape to wire (A).

Poppy seeds. These are attached to the stamens of flowers to give the appearance of pollen (B).

Hemp rope. Strands unraveled from hemp rope are used in making stamens.

Oil paints. Kneaded into the material before shaping, these paints give color to the entire mass. They may also be brushed on completed flowers (J).

Painting oil. Used to thin oil paints (I).

Cleansing agent. For cleansing brushes.

Tools

Press. This is employed to make flat, thin sheets from small pellets of Pando. The sheets become petals or leaves. You may substitute a rolling pin or the bottom of a metal can (O).

Shaping rod. This is used to shape and vary the petals and leaves made with the press (R).

You may substitute a chopstick or any suitably shaped rod.

Ball-headed shaping rod. This is extremely useful in bulging and forming large petals. You may substitute a spoon, but this tool is so convenient that it will repay whatever effort is required to procure it (Q).

Petal stand. This plate with three hemispherical bulges is convenient for holding rounded petals while they dry. You may substitute table-tennis balls or a small inverted bowl (P).

Leaf mold. After making the general shape of the leaf in the press, you can add veins by pressing the leaf against this mold. The mold is available in two types – I (M) and II (L) – which enable you to reproduce almost all kinds of leaf vein patterns. You may use natural leaves.

Scissors. You will need at least two pairs: medium (V) and small (W) scissors for making cuts in Pando and for cutting outlines of leaves and petals.

Wire-cutting scissors. These are necessary for cutting thin, single pieces of wire (U).

Pinking shears. These are useful for such operations as trimming the petals of cherry blossoms.

Wire-cutting pliers. These are used for cutting thick wires (T).

Hacksaw blade. This is used to cut styrofoam (S).

Brushes. For coloring and touching up dried Luna Flora you will need oil painting brushes in several sizes (K).

Palette. You will require this kind of palette or a plain, small dish to mixing oil paints (N).

Production Techniques

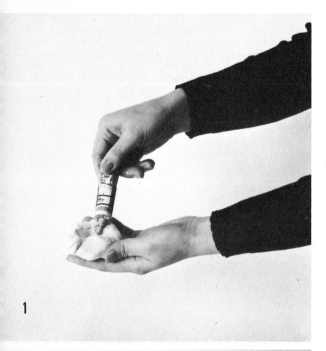

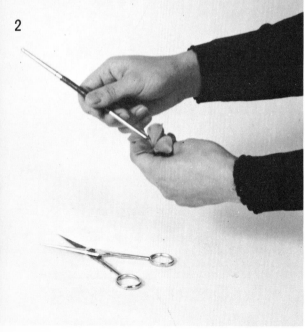

Using Pando

The following few simple rules will enable you to make best use of Pando.

Drying. Flowers and other forms made of Pando must be allowed to dry naturally. Place them so that the shapes will not be disturbed or broken and leave them for two or three days.

Base color. As shown in Photograph 1, apply the appropriate amount of oil paint directly from the tube to the Pando then knead well to distribute the color evenly. Use only small amounts of oil paint, because when the Pando has dried, the intensity of the color will approximately double.

Hardness. Pando must be neither too soft nor too hard. If it is so soft that it will not hold its shape, leave it uncovered and exposed to the air for a while until it is of the correct consistency. If it becomes too hard, it may be softened with a small amount of alcohol—even whiskey.

Storing. As is clear from the preceding rule, Pando hardens if left exposed to the air. When you are not using your Pando, store it in a vinyl bag or in plastic kitchen wrap.

Forming. In Luna Flora making, no patterns or molds are used. All petals, leaves, and other shapes are made from ball or pellet forms. They may be flattened with a press or adjusted, varied, and made more interesting with shaping rods and ball-headed shaping rods. Subtle touches are added with the fingertips, and the forms are allowed to dry naturally.

Shaping Petals and Leaves

After making basic flower petals and flower shapes, hold the Pando lightly, as shown in

Photograph 2, and add molding and sculptural details with the shaping rod. Apply the rod to the Pando in a rolling motion. The commercially available rods have large and small ends for convenience in working on flowers of different sizes. If the flowers you are making are so small that the shaping rod is clumsy to use, try working with a toothpick.

Each flower must have a wire stem. Before inserting one end of a piece of wire into the soft Pando, bend it to form a small loop and dip the loop in adhesive.

Wrapping Wire

As a general rule, all floral works in this book call for wrapped wire. If the wire you have on hand is not wrapped, be sure to cover it with floral tape. In order to give a more natural, subtle look to stems and branches, pad the wire with tissue paper, then cover this with another coat of floral tape (Photographs 3 and 4). Never wrap the floral tape at too sharp an angle and never pull it hard, for this will weaken it greatly.

When combining leaves and flowers, add a touch of adhesive to the end of the floral tape before beginning to wrap. For cherry boughs or camellias and other flowers with comparatively heavy branches, the best covering is cotton bias tape, but the entire surface of this tape must be coated with adhesive before wrapping.

Final Coloring

In preparing the colors for the final touching up, do not use too much painting oil, or you will produce a glossy finish that cheapens the appearance of the flowers. Furthermore, too much of this oil will cause the paints to discolor as time passes. Always have four or five brushes on hand so that you can use one for each color and always wash brushes thoroughly in turpentine or some other suitable cleaner after use. Paint the upper and under sides of leaves and make certain that

the oil paint has dried before you combine flowers, leaves, and stems. If you wrap stems with cotton bias tape, paint the cloth after wrapping.

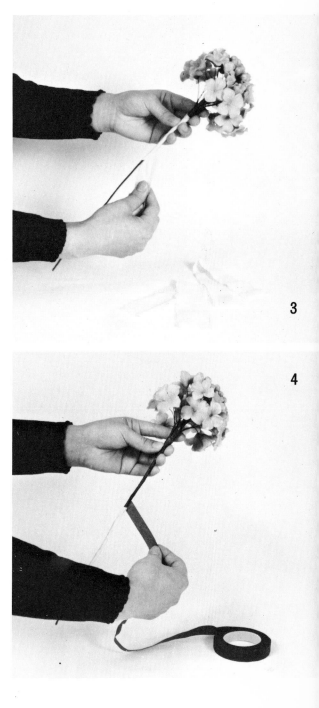

3

4

Making Luna Flora

Having explained the materials and tools called for in this craft, I can now begin describing the actual production of Luna Flora. The most important aspect of Luna Flora making is for you to understand the characteristics of Pando and for your fingers to become completely at home with its use. Begin by working with the material and making as many forms, leaves, petals, and other objects as are necessary for you to understand it. In this book, explanations are given for only one basic part when several identical ones are needed to complete the flower. Luna Flora making involves absolutely no patterns or rigidly established forms; consequently, putting parts together in the final stages may seem difficult. It is not, however, for if you carefully examine the illustrations and the reference color photographs, you will be able to see what the flower should look like and will then be able to approximate, or perhaps surpass, what is shown here.

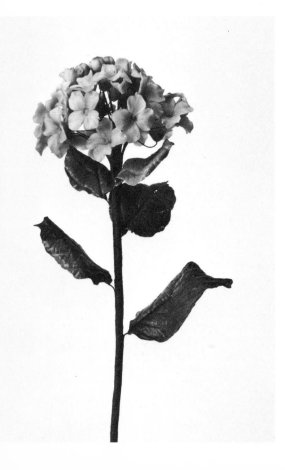

Hydrangeas

MATERIALS
Pando
Wire: numbers 24, 22, 20 and 14
Oil paints: purple, green, red (crimson lake), yellow-orange, and white
Painting oil
Floral tape: olive green
Adhesive

TOOLS
Wire-cutting scissors, small scissors, shaping rod, press, leaf mold I, and brushes.

FLOWERS
1. Cut a standard length of number 24 wire into 4 equal parts and bend a small loop in the end of each piece. Make forty of these looped pieces of wire.

2. You will need twenty open flowers. First tint the Pando pale lavender. Then make a small drop-shaped pellets about the size of peanuts. Using small scissors, make a cross-shaped incision in the thick end of each of

the pellets (Photograph 1). Using the shaping rod, press each of the four sections into an open petal (Photograph 2). Dip the loop end of a piece of wire in adhesive and insert it in the bottom of the flower. Thrust the other end of the wire into a block of clay or styrofoam and allow the flower to dry (Photograph 3).

3. You will need ten partly opened flowers. Just as in step 2, make peanut-size, drop-shaped pellets of Pando and make cross cuts in the thick end of each. Dip the loop

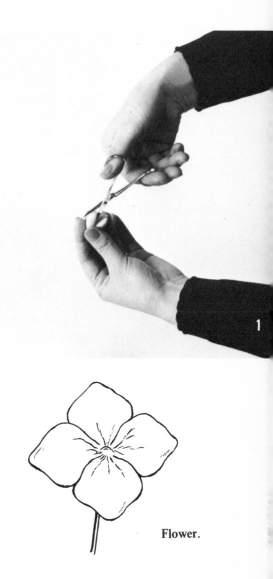

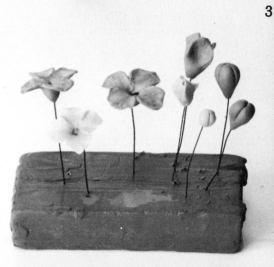

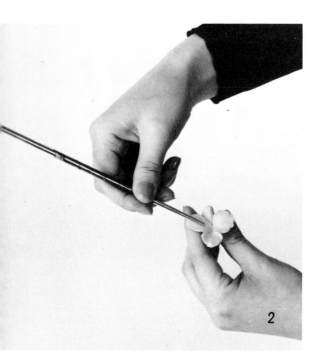

Flower.

end of a piece of wire into adhesive, insert it into the bottom of a flower. Pinch each resulting section to represent a partly open flower. When all are finished, allow them to dry. The partly open buds are fourth and fifth from the left in Photograph 3.

4. You will need ten unopened buds. As in step 3, make small drop-shaped pellets of Pando. Cut the thick end of each then lightly press the four sections together again. Add wire stems in the way explained in the preceding steps and allow the buds to dry. The unopened buds are sixth, seventh, and eighth from the left in Photograph 3.

5. Paint the base of each flower, partly opened flower, and bud with green to suggest calyxes.

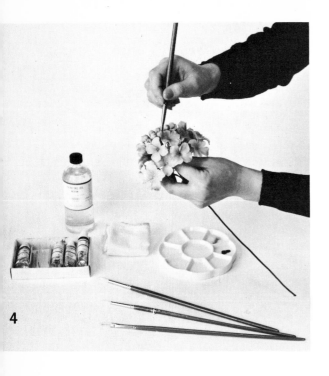

4

6. Combine four or five of the completely opened flowers by wrapping their stems together with half-width tape. Begin wrapping about three centimeters below the bottoms of the flowers. Align the individual units so that the flowers are all on the same level. Repeat this process with the remaining flowers and the half-open flowers.

7. For a central stem, select a piece of wrapped number 14 wire. Arrange the grouped flowers, half-open flowers, and closed buds in a circular bouquet around this wire. The buds must be in the center of the bouquet, the half-opened flowers next, and the open flowers on the outer edge. Attach these to the central stem with floral tape, which you must fix in place with adhesive as you wrap. At this point, adjust the number of blossoms needed to produce large or small hydrangea blooms.

8. Give the central wire a more realistic appearance by padding it with tissue paper and wrapping again with floral tape.

9. After the paper wrapping is finished, highlight each blossom and bud with soft tones of lavender and pink, taking care to reserve the total color effect of the blossom (Photograph 4).

LEAVES

10. First color the Pando green with oil paint. Next make long drop-shaped pellets of Pando; there must be 2 each of the following sizes: 10 centimeters, 7 centimeters, and 5 centimeters. Flatten each of these in the press (Photograph 5). Then press each against leaf mold I to create vein patterns (Photograph 6).

11. For use with the small leaves, cut a standard length of number 22 wire into 3 equal pieces; cut a standard piece of number 20 wire into 3 equal pieces for the larger and medium-size leaves. Coat one end of a cut piece of wire with adhesive. Place this on the top side of the center vein of a leaf; the wire must extend about one-third of the length of the leaf from the base. Pinch the Pando from the underside of the leaf so that it closes over the top of the wire and conceals it. Allow the leaves to dry undisturbed.

Leaf.

12. Add finished touches with paint to the leaves. Use pale green for the small leaves and darker green for the large and middle-size ones. Highlight the leaves with touches of crimson lake, yellow, and orange.

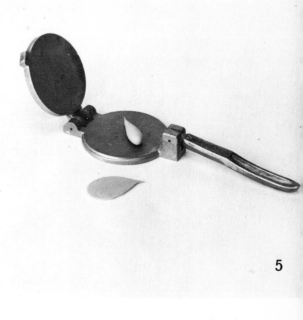

5

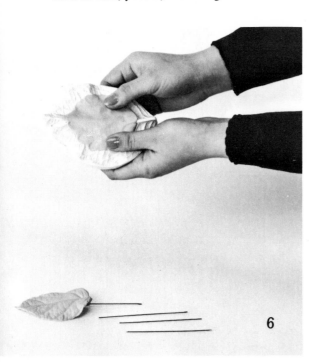

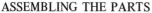

6

ASSEMBLING THE PARTS

13. When the paint on the leaves has dried, combine them with the bouquetlike cluster of flowers made in step 7. The smaller leaves should be nearer the top. Attach all the parts by wrapping them together with floral tape (Photograph 7). After you have finished wrapping, adjust the positions of the leaves and the blossom.

PRODUCTION AND DESIGN HINTS

Remember that subtle color variations characterize hydrangeas. When combining parts make a number of smaller clusters composed of half-open buds and closed buds. The more leaves you use with the flowers, the more natural the hydrangeas will look. After grouping several blossoms in a cluster, add extra leaves to set off the flowers. These extra leaves should be attached; to number 18 wire.

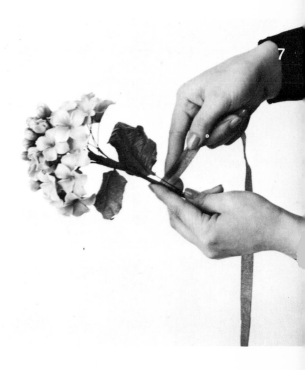

7

Cherry Bough

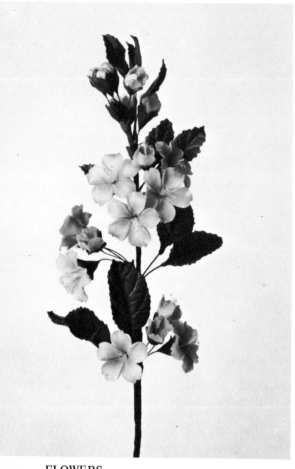

MATERIALS
 Pando
 Wire: numbers 24, 22, and 18
 Oil paints: rose-gray, white, and green-gray
 Painting oil
 Floral tape: olive green
 Adhesive
 Strands from hemp rope
 Poppy seeds
TOOLS
 Wire-cutting scissors, small scissors, pinking shears, press, shaping rod, leaf mold I, and brushes.

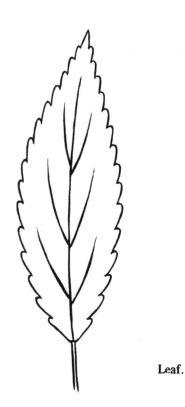

Leaf.

FLOWERS

1. Cut standard lengths of number 24 wire into 4 equal pieces and bend small loops in the end of each; you will need 17 pieces of wire.

2. You will need eight fully open blossoms. First tint the Pando pink by using a combination of a very small amount of rose-gray and some white oil paint. Next form Pando into small peanut-size, drop-shaped pellets. With small scissors, make five incisions in the thick end of each pellet. These cuts must divide the pellet end into five equal

42

segments that will become the five petals of the cherry blossoms. For the way these steps are executed, see the section on the hydrangea (p. 39).

3. Use a shaping rod to flatten and form each of the five petals. The petals of the cherry blossom have characteristic notches in the ends. Make them with pinking shears or small scissors. Dip the loop end of a piece of wire in adhesive and insert it into the bottom of the cherry blossom. Unravel a short piece of hemp rope. Cut three or four single hemp strands to lengths of between 2 and 3 centimeters. Fold them in half, dip the folded ends in adhesive, then insert them into the center of the cherry blossom. Insert the other end of the wire into a block of clay or styrofoam and allow the flower to dry thoroughly (Photograph 1).

4. Make half-opened flowers just as the fully open ones and insert hemp-strand stamens in their centers. Finally, lightly pinch the petals together (second from the left in Photograph 1).

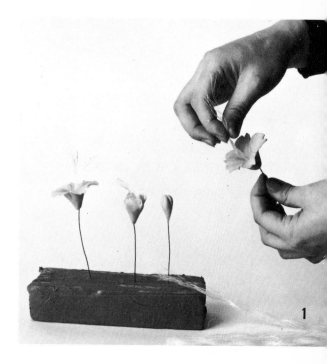

5. Cut the ends of the hemp stamens so that all strands in one flower are the same length. Attach one poppy seed to the end of each stamen with adhesive.

6. Each blossom and half-open blossom requires a calyx. Make these by shaping small drop-shaped pellets of Pando that has been colored with rose-gray paint. Cut the thick end of each pellet into five equal sections and, using a shaping rod, lightly form each section into a pointed part of a calyx. After putting adhesive inside the middle of the calyx, insert the stem of the blossom (Photograph 2). Do not round the bottom of the calyx, but allow it to remain long and pointed. In addition to open and half-open blossoms, make some buds and provide each with a calyx (third from left in Photograph 2). Allow all of these blossoms and buds to dry thoroughly.

7. When the calyxes are dry, highlight each with rose-gray and green-gray paint. Mixing open and half-open blossoms and closed buds, combine about six units by wrapping them in place with half-width tape (see step six of the hydrangea, p. 40).

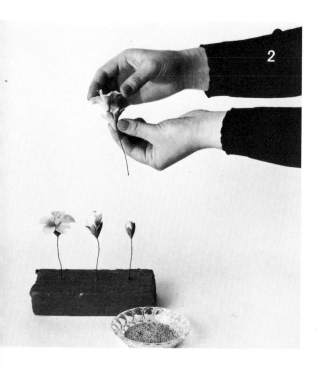

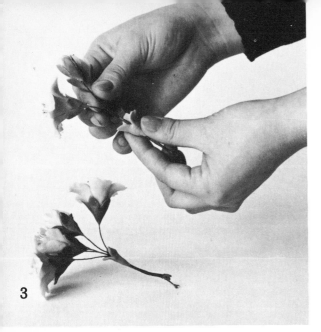

3

8. Cherry blossoms characteristically rise in clusters from a stipule. To make this stipule, first color some Pando rose-gray. Next shape it into a long, slender, drop-shaped pellet. Make slits that divide the thick end of the pellet into three equal parts. Examining Photograph 3 to get an idea of the shape of the stipule opening, form the Pando with a shaping rod. Apply a small amount of adhesive to the inside of the stipule. Then insert the stem of the combined cherry blossoms into the stipule, which must reach the point

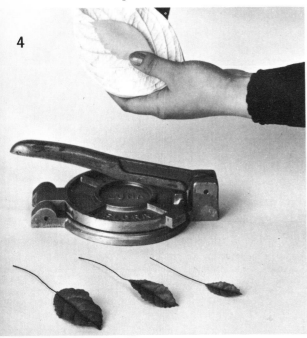

4

where the winding with half-width tape begins. When the stipule is dry, add color highlights.

LEAVES
You must make the following leaves in the indicated numbers.

large (5 to 6 centimeters)—3
medium (3 to 4 centimeters)—3
small (2 to 3 centimeters)—3
buds (1 centimeter)—2

Cut standard lengths of number 22 wire into 4 equal parts for the large and medium leaves; cut standard lengths of number 24 wire into 4 equal parts for the small leaves and buds.

9. From Pando that has been tinted rose-gray, make long, pointed, drop-shaped pellets of suitable sizes and flatten them in the press. Make vein patterns by pressing the leaves against leaf mold I. Then use your fingertips to give the edges of the leaves the serrate outline typical of cherry leaves.

10. Attach a suitable piece of wire to each leaf. Allow the leaves to dry thoroughly then add highlights with rose-gray and green-gray.

ASSEMBLING THE PARTS
11. Use 2 lengths of number 18 wire to make the stem. At the tip of the branch arrange a bud and four or five small leaves. Fix these in place by wrapping floral tape around their wires and the larger wire branch. Continue adding leaves and flowers, which must increase in size the farther you proceed down the branch. Be sure to cover all wire joints with floral tape.

12. When all the parts have been assembled into a cherry bough, add highlights of rose-gray and white paint to the blossoms.

PRODUCTION AND DESIGN HINTS
Unless the base color of the flowers is very pale, the finished bough will look dull. Take care to space the leaves and buds to seem natural and balanced. A single cherry bough is simple and beautiful in a tall vase.

Stock

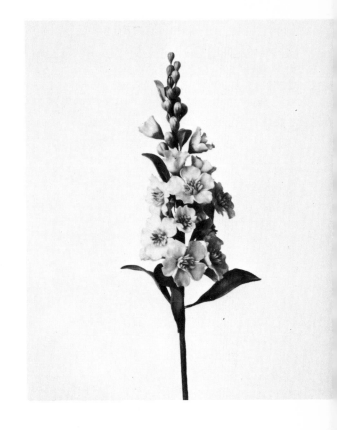

MATERIALS
Pando
Wire: numbers 24, 22, 18, and 14
Oil paints: green, yellow-orange, red (crimson lake), white, and purple
Painting oil
Floral tape: olive green
Tissue paper

TOOLS
Wire-cutting scissors, small scissors, shaping rod, press, and brushes.

FLOWERS

1. Cut standard lengths of number 24 wire into 4 equal parts and bend a small loop in one end of each piece. You will need thirty-one of these looped pieces.

2. You will need eight small and eight larger flower centers. To make these, first color some Pando a uniform, fairly dark purple. Make eight drop-shaped, peanut-size pellets of Pando; make eight more that are slightly smaller. Using small scissors, cut the thick end of each pellet in half. Then make several incisions in each half to create the fringe effect shown in Photograph 1. Dip the loop end of a piece of wire in adhesive and insert it into the bottom of the center. Use your fingertips to adjust the individual fringes to give a natural appearance. Allow the centers to dry.

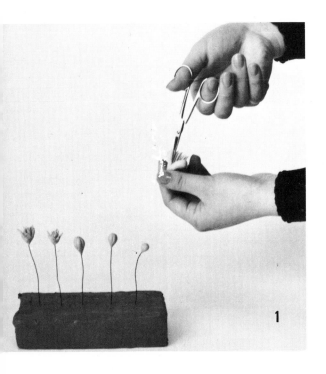

1

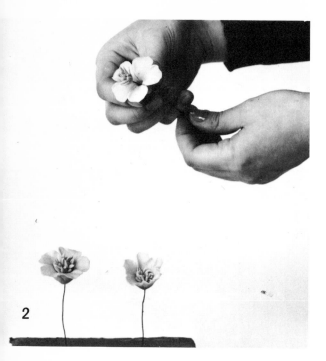

2

3. Make eight fully open flowers in the following way. Color some Pando a lighter purple than you used in the centers. Make drop-shaped pellets and cut the thick end of each into five equal sections. With a shaping rod, form each section into a longish, thin, flat petal, taking care to add natural curves. Put a touch of adhesive in the center of the set of petals. Insert the wire of one flower center into the center of a set of petals and allow the flower to dry. A fully opened flower is shown on the left in Photograph 2.

4. Make eight half-open flowers. These are made in the same fashion as the fully open flowers with a few exceptions: the petals are smaller; you use the smaller flower centers; after combining centers and petals, pinch the petals slightly inward (see flower on the right in Photograph 2). When all the flowers are finished, allow them to dry.

5. Make five each of the large, medium, and small buds. Following the directions for the hydrangea on page 39, divide each pellet of Pando into five equal sections by making incisions in the thick end. Allow the buds to dry (left bottom of Photograph 1).

6. Paint the bottoms of the flowers and buds green. Paint the small buds green almost all the way to the top.

LEAVES

Make the following leaves in the sizes indicated.

large (7 to 8 centimeters)—2
medium (5 to 6 centimeters)—2
small (3 to 4 centimeters)—2
buds (1 centimeter)—2 or 3

For large and medium leaves, use standard lengths of number 22 wire cut into 3 equal parts. For small leaves and buds use standard lengths of number 24 wire cut into 4 equal parts.

7. After coloring some Pando green, prepare long, slender, cylinder-shaped pieces. Flatten these in the press into something like the shape shown. For the large and small leaves, press a piece of wire into the center of each to make the central vein. To give a similar effect in the small leaves and in the buds, fold each in half with your fingers. Dip the end of each piece of wire into adhesive and attach it to the leaves. Allow the leaves to dry (Photograph 3).

8. Apply highlights and shading with oil paints—green, yellow-orange, crimson lake—to the leaves when they are dry. The smaller leaves must be bright in color, and the larger ones quieter and darker.

Leaf.

ASSEMBLING THE PARTS

9. The buds and blossoms are attached to the central stalk by means of floral tape. This stalk consists of a standard length of number 18 wire cut in half. Begin with one small bud, then add larger buds, leaves, half-open flowers,

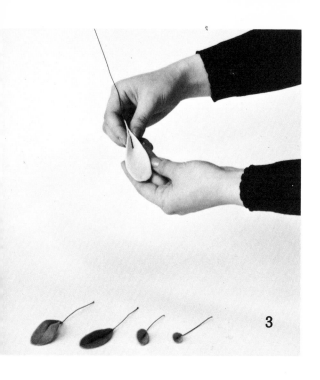

and fully open flowers in that order. Add leaves and buds at appropriate places along the stalk (see Photograph 4).

10. When you have added as many buds and flowers as are shown in Photograph 4, prepare a piece of wrapped number 14 wire by padding it with tissue paper. Fixing it in place with floral tape, add this wire to the first wire to make an extension and continue attaching flowers and leaves. The entire stalk ought to be about 20 centimeters long, and the medium and large leaves must be near the bottom.

11. When the parts are all assembled, add highlights with white and purple paint, taking care to maintain color balance throughout the stalk. Add accents of color to the centers of the flowers.

PRODUCTION AND DESIGN HINTS

Better effects are produced if you limit yourself to the light and dark grades of one, or at most two, colors instead of using many tones. A large mass of stock arranged artlessly in a big vase will brighten the corner of any room.

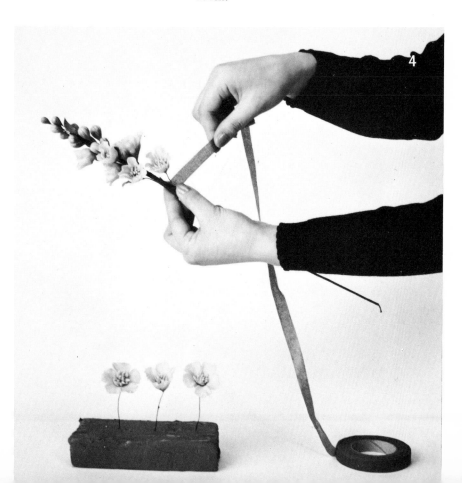

Lilies of the Valley

MATERIALS
Pando

Wire: numbers 26 and 20

Oil paints: white, blue, green, red (crimson lake), and yellow-orange

Painting oil

Floral tape: olive green

TOOLS
Wire-cutting scissors, small scissors, shaping rod, press, leaf mold II, and brushes.

FLOWERS

1. Cut standard lengths of number 26 wire into 4 equal parts each. You will need eighteen pieces. Bend a small loop in one end of each piece.

2. Make the flower centers in the following way. Color some Pando with a very small amount of pale blue paint. Shape the Pando into small pellets about the size and shape of a grain of rice. Dip the loop end of each piece of wire into some adhesive and insert it into the bottom of each pellet. A center is shown on the far right in Photograph 1. Allow the centers to dry.

3. Make eight fully open flowers in the following way. Using the same very pale blue Pando, make round pellets about the size of the end of your little finger. Make incisions that divide the tip of the pellet into six equal parts. Using the shaping rod form the flowers. Work from the inside to make the bulge in the bottom of the flower cup and from the outside to curl the petals back and out (see the line drawing). When the flower form is finished, insert a center and allow the flowers to dry.

4. Make six half-open flowers in the same way as the fully open blossoms, except that you must start with smaller petals and you must pinch the petals inward slightly after finishing the flower shape.

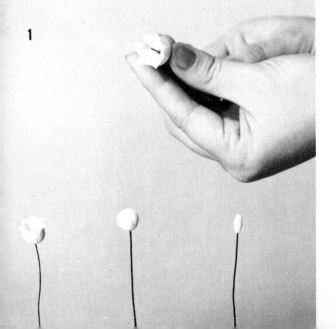

1

Flower.

5. Make three buds in the following way. Form round pellets of pale blue Pando about the size of green peas. Make incisions in one end of each pellet to divide its top into six equal parts. Lightly press the parts back together. Dip the looped end of a piece of wire into adhesive and insert it into the bottom of the bud. Allow the buds to dry. A bud is shown in the center of Photograph 1.

6. Paint the bottoms of open and half-open flowers and buds with light green.

LEAVES

7. After coloring some Pando green, form it into one large (10 centimeter) and one small (7 centimeter), long, narrow, drop-shaped pellet. After flattening these in the press, make vein patterns on their upper surfaces by pressing them against leaf mold II. Cut standard lengths of number 20 wire into 3 equal parts. After dipping the end of each in adhesive, attach each piece to a leaf. Finally, working from the underside, give the leaves interesting twists and curves. Allow them to dry.

8. When the leaves have dried, add highlights with green, crimson lake, and yellow-orange paint.

ASSEMBLING THE PARTS

9. Cut a standard length of number 18 wire in half. Using floral tape to hold it in place, attach a small bud to the very tip end of the wire. Continue down the stalk, adding buds, half-open flowers, and fully open flowers in that order. When all the flowers have been added, continue wrapping with floral tape to fill out the shape of the stem (Photograph 3).

10. Add highlights to the flowers and buds with blue and white paint. Use two or three leaves to each stalk of flowers.

PRODUCTION AND DESIGN HINTS

Lilies of the valley are appealing flowers. To give full representation to their charming appearance, make the flowers small, round, and not too long. In the total composition, as well as in the individual flowers, keep small-

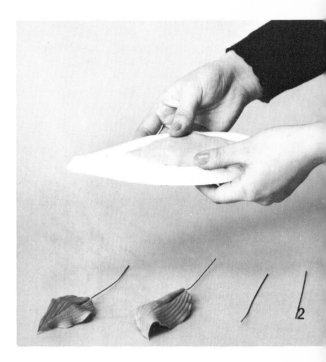

ness and charm in mind as the keynote. Accented with white ribbon, lilies of the valley make attractive presents or cheering gifts for people who are ill.

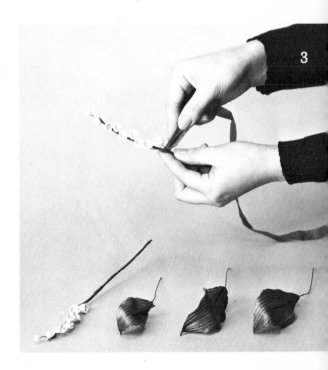

Daisies

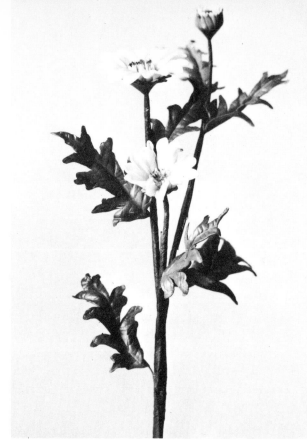

MATERIALS
Pando
Wire: numbers 22 and 18
Oil paints: white, blue, yellow, green, and red (crimson lake)
Painting oil
Floral tape: olive green
Tissue paper

TOOLS
Wire-cutting scissors, small scissors, medium scissors, shaping rod, press, leaf form I, and brushes.

FLOWERS
1. Bend a small loop in the end of a standard length of number 18 wire.

2. You will need one large, one medium, and one small flower center. They are all made exactly the same way except for size. First color some pando yellow then, for the large center, make a round ball about the size of the end of your thumb. Thrust one point of a small pair of scissors into the center of the Pando ball. Then make incisions at close intervals all around the ball to form a kind of fringe. Cut this open at the bottom so that it makes a long fringed strip. Dip the loop of the wire in adhesive, place it at one end of the fringed strip, and wind the strip round it. Take care that the edges are even. Do not allow the fringes to become too long. If there is any excess Pando, shave it off at the bottom with the scissors (Photograph 1).

3. To make the fully open flower, tint some white Pando with a very small quantity of blue. Make a round ball about the size of the end of your thumb. Thrust one point of a pair of medium scissors into the center of this ball. Starting from this point, make enough incisions around the ball to give seventeen or eighteen petals. Using the shaping rod, form

each of these sections into a petal. Put a small amount of adhesive on the bottom of the large daisy center made in the preceding section. Insert the daisy-center wire into the center of the set of petals (Photograph 2).

4. The partly open flower is made in exactly the same way, though it is slightly smaller. When you have inserted the flower center into the set of petals, press the petals inward.

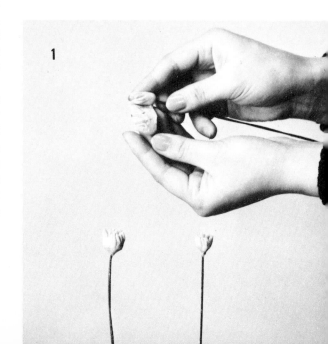

5. The bud too is made in a similar fashion. Use the smallest of the daisy centers and surround it with a small set of petals. Allow the open flower, half-open flower, and bud to dry.

6. Pad the stems of each with tissue paper and then wrap them in floral tape.

7. For the calyxes for flowers and buds, color some Pando green. Make balls of Pando in sizes somewhat smaller than those used for the petals of the flowers and buds. Following the method for the petals, make slits all around each ball from the center. Flatten these into appropriate shape with a shaping rod, put a dab of adhesive in the center of each calyx and insert the stem of one of the flowers or of the bud into its center. The bottom left flower in Photo 2 shows a daisy with calyx.

8. When the flowers are dry, paint the petals white and use a very small amount of crimson lake for shading. Employing stronger colors, add highlights in crimson lake and green to the centers and calyxes.

LEAVES

For each daisy make one each of the following leaves in the sizes indicated.

> large (6 to 7 centimeters)
> medium (4 to 5 centimeters)
> small (3 to 4 centimeters)

9. Color some Pando green. Make long, narrow, drop-shaped pellets the lengths shown above. Flatten these in a press and, using medium scissors, serrate the leaves as shown in the photograph on page 50. Add vein patterns by pressing the leaves on leaf mold I. Cut standard lengths of number 22 wire into 3 equal parts, put a dab of adhesive on one end of each, and attach one to each leaf. Allow the leaves to dry.

10. When the leaves are dry, add highlights of green, yellow-orange, and crimson lake. The smaller leaves are brighter and more lightly colored than the larger ones.

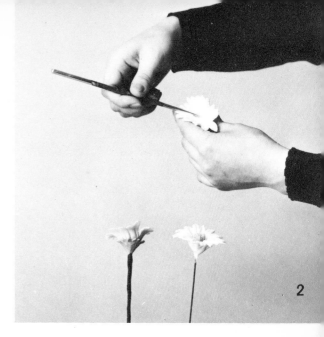

ASSEMBLING THE PARTS

11. Attach the leaves to the flower stalks made earlier, beginning at the top with the smaller leaves.

PRODUCTION AND DESIGN HINTS

Because the daisy has many petals of the same size and shape, be especially careful to vary their positions to prevent the flowers from looking stiff and monotonous. Flowers, buds, and leaves of different lengths combined in a small basket make an attractive foyer ornament or a pleasing gift.

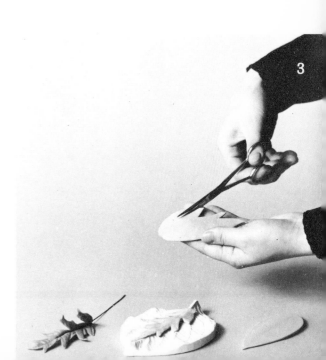

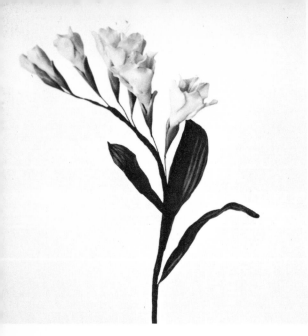

Freesias

MATERIALS

 Pando

 Wire: numbers 24, 22, and 18

 Oil paints: yellow, orange, green, and red (crimson lake)

 Painting oil

 Floral tape: olive green

 Vinyl adhesive

 Strands from hemp rope

 Poppy seeds

TOOLS

 Wire-cutting scissors, small scissors, shaping rod, press, leaf mold II, brushes.

FLOWERS

1. Cut standard lengths of number 24 wire into 3 equal parts; you will need 7 such pieces of wire.

2. Make three fully open flowers in the following way. First color some Pando pale yellow. From pieces of Pando about as big as the end of your thumb, make long, narrow, drop-shaped pellets. Make six incisions to divide the thick end of each pellet into six equal parts. These incisions are somewhat long. With a shaping rod, form the petals, which, as the line drawing on this page shows, are pointed and almost diamond shaped. Next

bring the petals upward and toward the center so that every other petal is on the inside and the alternate petals are on the outside (Photograph 1). Fold two or three short strands of hemp from a rope in half, dip the folded end in adhesive and attach this to the center of the flower to form stamens (see cherry p. 43 for further details on how this is done).

3. Make the half-open flowers in the same way, but use less Pando. The petals are brought closer to the center and no hemp-rope stamens are employed (the middle flower in Photograph 2).

4. For the buds use even less Pando than for the half-open flower. Make only three incisions and lightly shape the petals with the shaping rod. Bring them together as shown in the right in Photograph 2.

5. When the open flower has dried, trim the lengths of hemp strand so that they are all even and attach a poppy seed to the end of each with adhesive.

Petals opened.

1

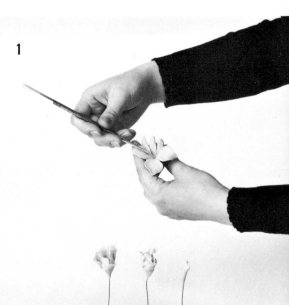

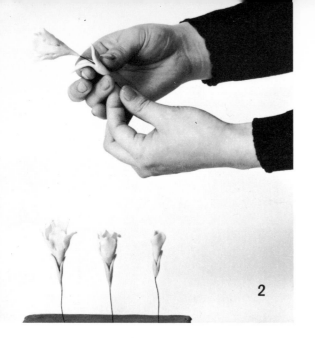

2

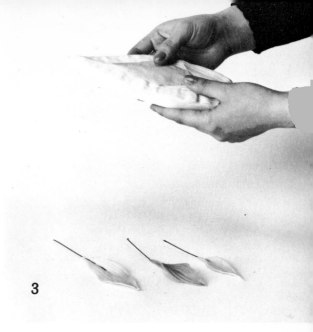

3

6. For the calyxes, color some Pando green. Form long, narrow, drop-shaped pellets. Make an incision that divides the thick end of each into sections that are two-thirds to one-third in proportion; that is, one section of the calyx is considerably larger than the other (Photograph 2). Shape the calyx with the shaping rod. Put adhesive in the center of the calyx and on the bottom of each flower and bud. Combine the parts by inserting the wire of each flower and bud into the center of a calyx. Allow the flowers to dry. Notice that the calyxes are long (Photograph 2).

LEAVES

7. After coloring some Pando green, make a long (8 to 9 centimeters), drop-shaped pellet. Flatten it in the press. Add vein patterns by pressing the leaf against leaf mold II. Cut a standard length of number 22 wire into 3 equal parts. Put some adhesive on the end of a piece and attach it to the underside of a leaf. Lightly shape the leaf to give it an interesting form (Photograph 3). Make three such leaves for one stem and allow them to dry.

COLORING

8. Add dark and light places to the petals with orange and yellow; highlight and shadow the calyxes and leaves with green and crimson lake.

Leaf.

ASSEMBLING THE PARTS

9. Use a piece of number 18 wire for the basic stem. Wrapping with floral tape, begin with the small buds and add the half-open and open flowers in that order. Place the three leaves at the bottom.

PRODUCTION AND DESIGN HINTS

The characteristic of the freesia is that three petals are inside the other three. Even in full bloom, the flower does not open wide. Take care to give each spray of freesia a beautiful natural curve.

53

Daffodils

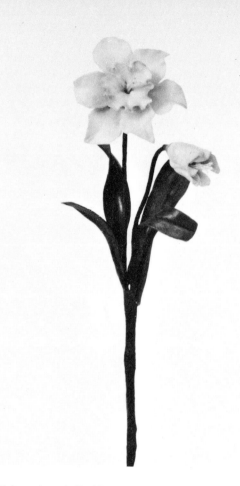

MATERIALS
Pando
Wire: numbers 20 and 18
Oil paints: yellow, green, and red (crimson lake)
Painting oil
Floral tape: olive green
Tissue paper
Adhesive
Strands from hemp rope
Poppy seeds
TOOLS
Wire-cutting scissors, small scissors, shaping rod, press, and brushes.

FLOWERS
1. Pad 2 standard lengths of number 18 wire with tissue paper and wrap each in floral tape. Bend a small loop in the end of each.

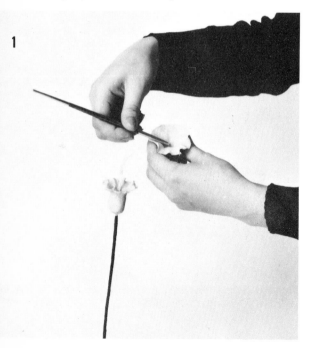

2. Make the daffodil trumpet by first coloring some Pando yellow and then making a ball about the size of a soy bean. Thrust the end of the shaping rod into the center of the ball of Pando. Twisting the rod gently, gradually hollow the ball with the rod. Then frill the edge of the trumpet. Put a dab of adhesive on the end of one of the pieces of wrapped wire and insert it into the center of the bottom of the trumpet. Fold two or three short strands of hemp in half, dip the folded end in adhesive and embed this into the center of the trumpet (Photograph 1).

3. For the petals of the open flower, color some Pando pale yellow. From this make a ball about as big as the end of your thumb. Cut the top of the ball into six equal sections and, using the shaping rod, form each of these into a petal. Notice that each petal is roughly diamond shaped with a somewhat pointed outer edge (Photograph 2).

4. Put a dab of adhesive in the center of the set of petals and insert the wire of the

trumpet. Make a center line by pinching each of the petals lightly from the underside. Press the petals with the fingers into pleasing curved shapes, taking care that three alternating petals are inward and three alternating petals outward as is characteristic of the daffodil.

5. The bud is made like the petals of the open flower, though it is necessary to use a smaller ball of Pando. Since there is no trumpets, the hemp-rope stamens are attached directly to the petals, which are then pressed inward toward the center (Photograph 3, right stalk).

6. When the flower and bud are dry, trim the hemp strands to the same length and attach a poppy seed to the end of each with adhesive.

7. Paint the parts that correspond to the calyx in the bud and flower green. Paint the base of the turmpet dark yellow and the edge orange.

LEAVES

8. Make six leaves in the following way. After coloring some Pando green, shape it into a long (10 centimeters), narrow cylinders. Flatten these in the press. Trim the ends of the leaves into the characteristically squarish shape. Cut standard lengths of number 20 wire in half and dip one end of each in adhesive. Make the center line of the leaf by folding with your fingers. Attach the wire and allow the leaves to dry.

9. When they are dry, give the leaves shadows and highlights with dark green and crimson lake.

ASSEMBLING THE PARTS

10. Bind the stems of the bud and the fully open flower together with floral tape and add the leaves.

PRODUCTION AND DESIGN HINTS

Take special care to preserve correct proportions between the sizes of the trumpet and the petals. Daffodils are very attractive combined with tulips.

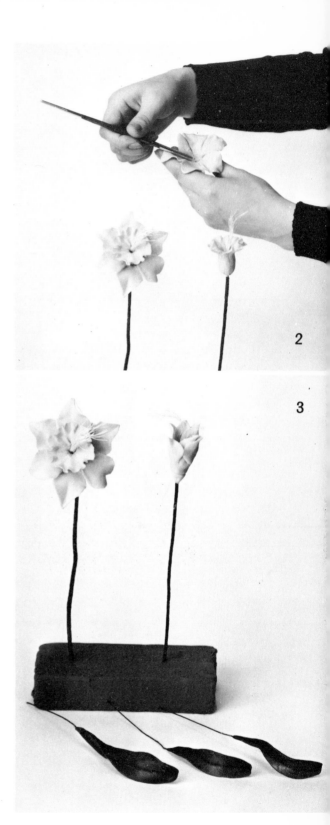

2

3

Sunflowers

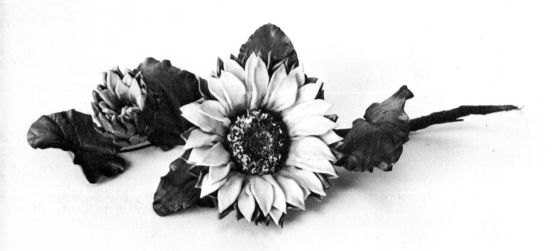

MATERIALS
Pando
Wire: numbers 18 and 14
Oil paints: yellow, green, brown, and red (crimson lake)
Painting oil
Floral tape: olive green
Styrofoam
Adhesive
TOOLS
Wire-cutting scissors, medium scissors, shaping rod, toothpick, press, lead mold I, brushes, and hacksaw blade.

1

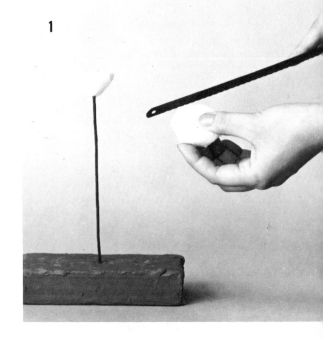

FLOWER

1. Begin by making the center. Use a hacksaw blade to cut a disk of styrofoam about 2 centimeters thick and about 3 centimeters in diameter. Cut the bottom side to a point so that the resulting form looks like a child's play top. Bend a small U-shape in the end of a piece of wrapped number 14 wire. Dip the bent end in adhesive and insert this through the top of the styrofoam so that the U hooks firmly inside. Pad the protruding stem with tissue paper and wrap it in floral tape (Photograph 1).

2. After coloring some Pando brown, take a piece about the size of the end of your thumb and round it. Flatten this to a diameter of about 4 centimeters in the press. Apply a coat of adhesive to the styrofoam center and attach the brown Pando to it. Press the Pando firmly against the styrofoam on all surfaces. Make a slight depression in the upper middle of the flower center. With the dull end of a toothpick, make a number of pits in the depressed area. Next, with the sharp end of a toothpick make rough marks over the upper surface (Photograph 2).

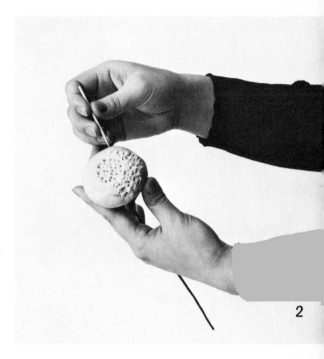

2

3. Color some Pando yellow for the petals. Take a piece about as big as the end of your thumb, round it into a ball, and from the tip make incisions that divide the ball into four equal parts. Using the shaping rod, press each of the four sections into a long, pointed petal. When all four petals are formed, cut the bottom of the piece of Pando so that the petals form a single straight line. Gather the bottom of this set of petals (Photograph 3), coat it with adhesive, and attach it to the side of the flower center. Continue with the process until the center is surrounded with petals. Allow the flower to dry.

4. The bud is made in exactly the same way except that it is smaller and its petals are pressed upward to the center.

5. Next color some Pando green for the calyx, which is made in two ranks. Take a piece of Pando about the size of the end of your little finger. Roll it into a long, narrow,

drop-shaped pellet and make incisions that cut the thick end of the pellet into four equal parts. Use the shaping rod to form each part into a long, slender, leaflike section. These

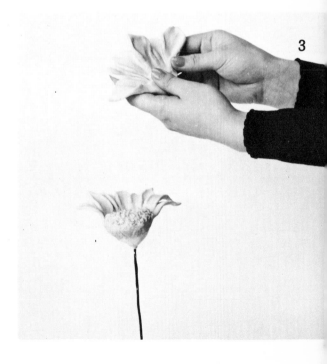

3

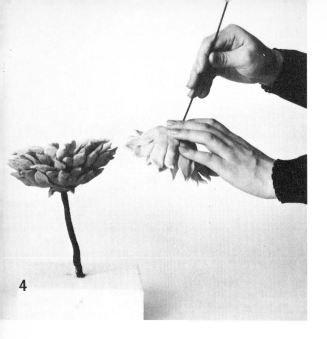

4

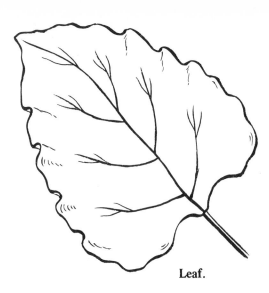

Leaf.

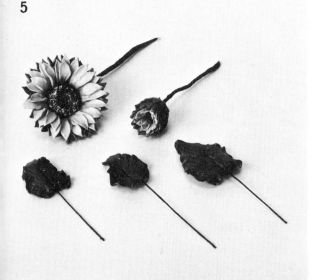

5

sections are more slender than the yellow flower petals. After all four have been properly shaped, cut the bottom of the Pando so that the leaflike sections form a strip. Coat the lower part of this strip with adhesive and attach it to the underside of the petals. When seen from the top of the flower, the sections of the calyx should fall between the yellow petals. Continue with this process till you have surrounded the flower with one rank of calyx sections.

6. The second rank of calyx sections is made and applied in the same fashion but is placed lower. The bottom of the second rank must come to the stem of the flower. Where it reaches this point, make three of four incisions and curl pieces of Pando back to suggest the bract (Photograph 4).

LEAVES

7. Make long, tapering pellets of green Pando and flatten them in the press. Add vein patterns by pressing the leaf shapes against leaf mold I. Use the shaping rod to put natural undulations in the outer edge of the leaves (see line drawing and Photograph 5). Cut a standard length of number 18 wrapped wire in half. Attach one piece to each leaf with adhesive. Allow the leaves to dry.

8. Use one large, one small, and one medium leaf for each set of one bud and one blossom (Photograph 5).

COLORING

9. Use green, crimson lake, and yellow to highlight the center of the sunflowers, color the petals yellow and shade them with crimson lake, and use crimson lake and yellow-orange to highlight the calyx and leaves.

ASSEMBLING THE PARTS

10. Bend the stem slightly at the base of the flower. Add the leaves in this order: small at the top, medium next, large last.

PRODUCTION AND DESIGN HINGS

The petals must be as long as the radius of the flower center. With flowers like this it is best not to attempt elaborate arrangements: they are most pleasing in a large-mouthed, massive vase.

Rambler Roses

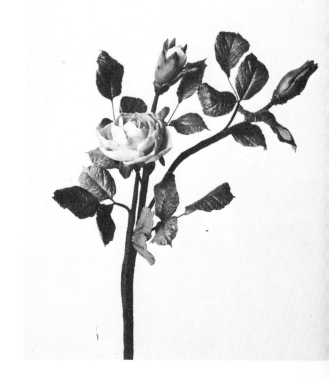

MATERIALS
 Pando
 Wire: numbers 22, 18, and 14
 Oil paints: yellow, green, orange, and red (crimson lake)
 Painting oil
 Floral tape: olive green
 Tissue paper
 Adhesive

TOOLS
Wire-cutting scissors, medium scissors, small scissors, shaping rod, press, leaf mold I, and brushes.

FLOWERS
1. Pad a 30-centimeter piece of number 14 wire with tissue paper. Wrap it again with floral tape and bend a small loop in one end. Make three of these.

2. You will require three flower centers, which need not be colored since they will be concealed by the petals. The largest should be a flattish ball (Photograph 1, left bottom) about the size of a marble. There should be a medium and a small one as well. For the bud, the center is smallest and must be somewhat long and pointed. Dip the looped end of each piece of wire in adhesive and insert into a flower center. Allow these to dry.

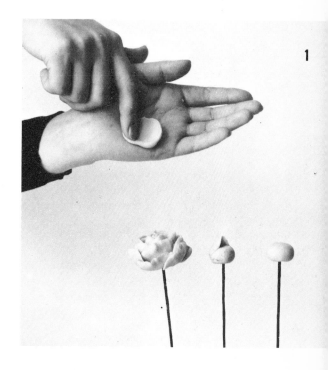

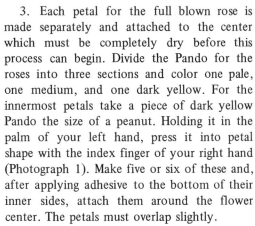

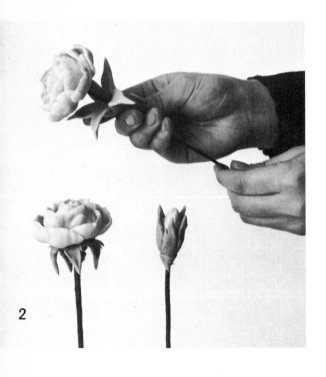

3. Each petal for the full blown rose is made separately and attached to the center which must be completely dry before this process can begin. Divide the Pando for the roses into three sections and color one pale, one medium, and one dark yellow. For the innermost petals take a piece of dark yellow Pando the size of a peanut. Holding it in the palm of your left hand, press it into petal shape with the index finger of your right hand (Photograph 1). Make five or six of these and, after applying adhesive to the bottom of their inner sides, attach them around the flower center. The petals must overlap slightly.

4. The medium yellow is used for the inner most and the pale yellow for the outermost rows of petals. Take care that the petals increase in size as you move farther from the center. Make five or six petals of each color and attach them as you did the dark ones in the first row.

Petal.

5. The partly open rose is made in the same way except that only from three to six petals are required in all.

6. Make the calyx from Pando colored green. From a piece about the size of the end of your little finger, make a long slender, drop-shaped pellet. Cut the thick end of the pellet into five equal parts. Using the shaping rod, bulge only the inner parts of these section. The tips must remain long and slender (see the line drawing on the next page for the shape of the calyx). Put a dab of adhesive in the center of the calyx and insert the wire stem of a flower. When the calyx is in proper position (Photograph 2), use scissors to make a groove around its base to suggest the hip of the rose (see the bud on the left in Photograph 3). Then cut sharp thorns in the edges

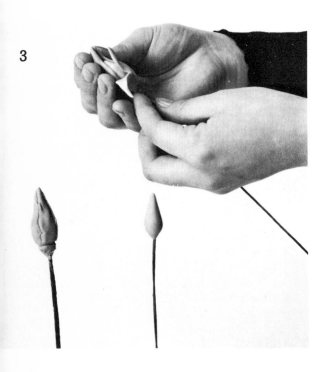

2

3

Calyx and bud are made in this shape.

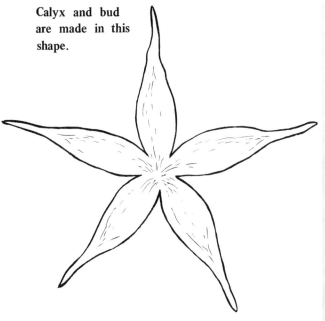

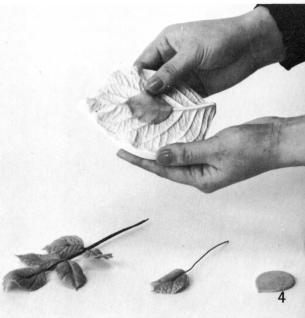

of the calyx sections. Curve the calyx sections down naturally and allow the flower to dry.

7. The bud is made exactly like the calyx and is attached to the pointed bud center made earlier. When the individual sections of the bud surround the center they must have the same jagged, thornlike edge as the calyx of the full-blow rose (Photograph 2).

LEAVES

8. Cut a standard length of number 22 wire into 4 equal parts. You will need twenty of these pieces.

9. Make drop-shaped pellets of green Pando about 5 centimeters long (see explanation of the small hydrangea leaves on p. 40). Flatten these pellets in the press. Make vein patterns on the leaves by pressing them against leaf mold I. Attach the pieces of wire to the undersides with adhesive and shape the leaves naturally before allowing them to dry. Make three sets of leaves in three sizes.

10. Rose leaves are combined either three or five to a stipule. In sets of three, the leaf at the end of the branch is medium sized, and the ones on the right and left are small. In sets of five, the end leaf is large, and the ones on the right and left are medium.

COLORING

11. Add light and dark places to the flowers with yellow and orange paints. The leaves and buds may be highlighted and shadowed with green and crimson lake. Remember that the smaller leaves are lighter in color.

ASSEMBLING THE PARTS

12. Use one set of three leaves and one set of five leaves with each flower. Each set must be placed so that the tip of the top leaf is on a level with the blossom.

PRODUCTION AND DESIGN HINTS

Since rose petals are numerous, they must be carefully overlapped. In placing them, always try to create a feeling of variety. You can avoid monotony in your arrangements if you always combine light and dark flowers. Do not use long stems for these roses, which tend to be heavy.

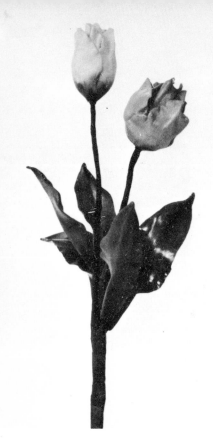

Tulips

MATERIALS

Pando
Wire: numbers 20 and 18
Oil paints: green and red (crimson lake)
Painting oil
Floral tape: olive green
Tissue paper
Strands from hemp rope
Adhesive
Poppy seeds

TOOLS

Wire-cutting scissors, medium scissors, press, shaping rod, and brushes.

FLOWERS

1. Tape two lengths of number 18 wire together. Bend a loop in the end, pad with tissue paper, and wrap again with floral tape. For the full-blown tulip, prepare stamens in the following way (stamens are unnecessary for buds). Cut strands from hemp rope into 5- or 6-centimeter lengths, fold 2 or 3 of these lengths in half together, and attach them to the loop of the wrapped wire.

2. You must now make one large and one small flower center. First color some Pando red. Take a piece of this Pando about as big as the end of your thumb. Put a small amount of adhesive on the bent end of the wire and shaped pellet with a conical bottom (Photograph 1, bottom center and right). For the full-blown tulip, the hemp-strand stamens will emerge from the pinnacle of this flower center.

3. The petals of the full-blown tulip are applied in two steps. First make a long, drop-shaped pellet of red Pando from a piece somewhat larger than that used for the flower center. With medium scissors, make incisions that divide the thick end of the pellet into three equal parts. Using the large end of the shaping rod and holding the Pando as shown in Photograph 1, form each petal. Put a small amount of adhesive in the center of the set of petals and insert the wire of the flower center. Bring the petals to the center to make a form like the one on the far left in Photograph 1. Hold the flower upside down and make still deeper cuts between the petals. This will enable you overlap the petals to a greater extent.

4. Make the second set of petals just as you made the first. After putting a small amount of adhesive in the center of the second set, insert the stem of the tulip. Lightly grip the petals to prevent them from opening too wide (Photograph 2). Allow the flower to dry. Then trim the hemp strands so

1

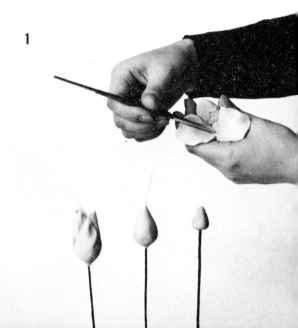

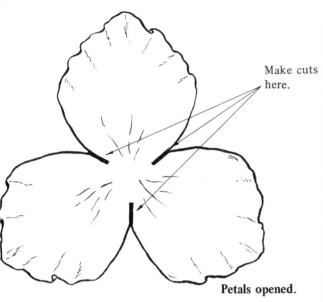

Make cuts here.

Petals opened.

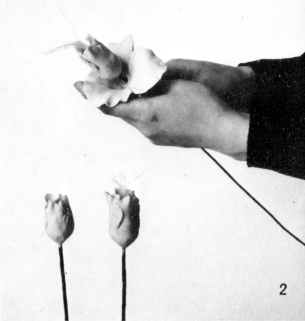

2

that they are the same length and attach a poppy seed to the end of each.

5. The bud is made in the same way as the open flower except that all the parts are smaller and the petals must be pressed still more inward. The bud is shown in the lower left of Photograph 2. Allow the bud to dry.

LEAVES

Make one each of the following leaves.

large: (about 10 centimeters)
medium (about 8 centimeters)
small (about 6 centimeters)

For the large leave use half of a standard length of number 18 wire. For the small and medium leaves, use one third of a standard length of number 20 wire.

6. First color some Pando green. Make long, narrow, drop-shaped pellets the sizes indicated above and flatten them in the press. Attach a piece of wire to the underside of each with adhesive; the wire must run about one-third the length of the leaf. Fold each leaf in half lengthwise with your fingers to create the center line. Allow the leaves to dry.

COLORING

7. The flowers should be painted in dark red with a touch of green on the undersides.

8. Add highlights and shadows to the

leaves with green, yellow-orange, and crimson lake. The smaller leaves must be brighter and lighter in color than the larger ones (Photograph 3).

ASSEMBLING THE PARTS

9. In general, use three leaves to one flower and arrange them so that they surround the stem from three sides.

PRODUCTION AND DESIGN HINTS

Design these flowers to take advantage of the length of their stems and to emphasize their handsome appearance when seen from the side.

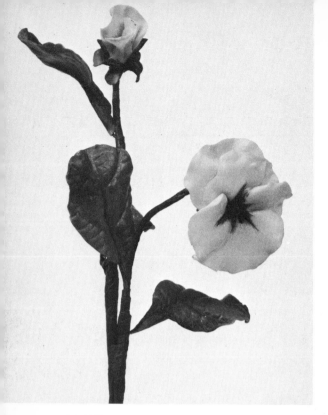

MATERIALS
 Pando
 Wire: numbers 22 and 18
 Oil paints: purple, yellow, green, and red
(crimson lake)
 Painting oil
 Floral tape: olive green
 Tissue paper
 Adhesive
TOOLS
 Wire-cutting scissors, small scissors, shaping
rod, press, leaf mold I, and brushes.

1

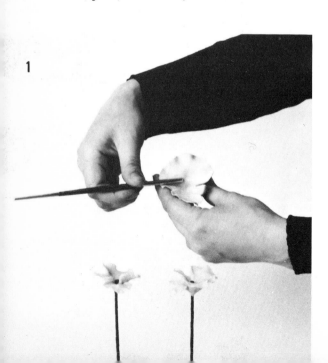

Pansies

FLOWERS
 1. After padding a piece of number 18
wire with tissue paper and wrapping it with
floral tape, cut it in half and make a hook in
one end of each of the pieces. Take care that
the winding is neat because, in this case, it
will show in the center of the flower.
 2. Color some Pando purple. Make a ball
of the Pando about the size of a large marble.
Make a cut that divides the top of the ball in
half. Next make another incision that cuts one
of these halves in half; that is, you will need
three sections for one large and two small
petals (see line drawings on the opposite
page). Form the petals (Photograph 1) with a
shaping rod. The large petal must overlap the
smaller petals slightly.
 3. Put some adhesive on the hooked end
of a piece of wrapped wire. Insert this into
the center of the set of petals, allowing a
small bit of the wire to remain visible. Allow
the first set of petals to dry.
 4. Now make a second set of petals to be
attached to the bottom of the first set (see
line drawings). To do this, take a piece of
purple Pando slightly smaller than the one
used in making the first set of petals. Roll it
into a ball and make an incision that divides it
in half. Using the shaping rod, form each half
into a petal. Allow one petal to overlap the
other as shown in the line drawing. Apply a
small amount of adhesive to the middle of
these petals and insert the wire stem of the
first set of petals through them. Allow the
flower to dry (Photograph 2).
 5. For a half-open pansy, follów the pro-
cedures for the first set of petals of the fully
open flower, but make them smaller. You will
not require the second set of petals. Insert a
bent and wrapped length of number 18 wire
just as in the fully open flower and lightly
press the petals inward. Allow the flower to
dry.
 6. The calyx for each flower is made in
two stages and calls for Pando that has been

First set of petals.

Second set of petals.

The flower is made by putting the first set of petals on top of the second set of petals.

colored green. Taking a piece of Pando slightly larger than a green pea, shape it into a ball, make incisions that divide the top into five equal parts, and form each section into a pointed leaflike projection. This will become the upper part of the calyx. Apply a dab of adhesive to the center and insert the wire of the flower into the calyx.

7. Make the lower section of the calyx in the same way but do not curl the projections as sharply (Photograph 3). Attach this to the underside of the first calyx section with adhesive. Allow the flower and calyx to dry. A completed flower and calyx is seen in the middle right of Photograph 3.

LEAVES

8. Color some Pando green. Make a slender, drop-shaped pellet about as large as the end of your little finger and flatten it in the press. Using leaf mold I, press vein patterns into the surface. Adjust and vary the shapes with your fingertips. Cut standard lengths of number 22 wire into 4 equal parts. Attach one piece to each leaf with adhesive.

COLORING

9. If the flower is dark purple, use yellow in the center. The calyx and leaves are green with crimson lake shading.

ASSEMBLING THE PARTS

10. Place the fully opened flower below the bud and arrange large, medium, and small leaves around them (see photograph on p.64).

PRODUCTION AND DESIGN HINTS

In assembling the flowers, take care to bend the wire so that the big petal of the pansy is down and the small ones up. Since pansies have short stems they are well suited to low containers and small baskets.

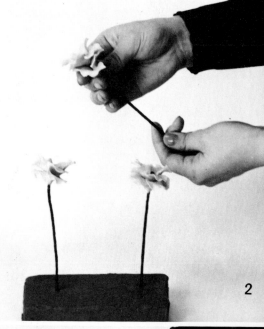

2

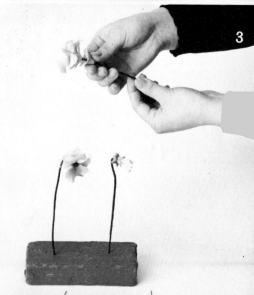

3

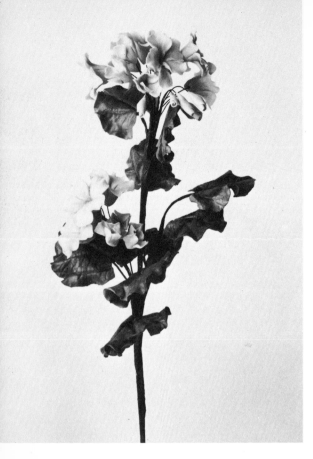

Geraniums

MATERIALS

Pando
Wire: numbers 24, 22, 18, and 14
Oil paints: orange, green, and red (crimson lake)
Painting oil
Floral tape: olive green

TOOLS

Wire-cutting scissors, small scissors, shaping rod, press, leaf mold I, and brushes.

FLOWERS

1. Cut standard lengths of number 24 wire into 4 equal parts and bend a small loop in one end of each. Prepare twenty-six such pieces of wire.

2. For the fully open flowers color some Pando orange. Make a round ball of this material about the size of a peanut. Make

incisions that divide the top into five equal sections. With a shaping rod, form each section into a petal like those shown in the line drawing. The petals are almost flat (see the hydrangea, p. 39, for reference). You will need sixteen flowers. After having shaped the petals, use small scissors to extend the incisions between them. Pressing some petals upward from below, give each flower movement and variety. Dip the looped end of each piece of wire in adhesive. Insert the wire into the center of a flower. When all the flowers have been set on wires, allow them to dry.

3. Make ten buds in the following manner. Make a small ball of orange Pando in the palm of one hand. With the index finger of the other hand lightly press the ball until it is a thin petal-shaped sheet. Then roll the sheet over and over (see the line drawing on p. 66 and Photograph 1). Dip the looped end of a piece of wire in adhesive and insert this into a bud. Make ten of these. Half-open flowers are made exactly like fully open ones except that the petals are pressed upward and to the center. From left to right, Photograph 1 shows fully open flowers, half-open flowers, and buds. When all of these have been made allow them to dry.

4. Paint the bottoms of the undersides of flowers and buds to represent calyxes.

Flower *(left)* **and bud** *(right).*

LEAVES

5. Make tapering pellets of green Pando about the size of the end of your thumb. Flatten them in the press. Take a pie-slice piece out of one end of the leaf (see the far

right in Photograph 2). Use leaf mold I to press vein patterns into the leaves and give the edges natural undulations with the shaping rod. Make stems by cutting standard lengths of wrapped number 22 wire into 4 equal pieces. Attach these stems to the leaves with adhesive. For one stalk of geranium you will require three each of large, medium, and small leaves.

6. The small leaves are colored green. The larger ones are green too, but you should add a circular shaded area of crimson lake to the center of each.

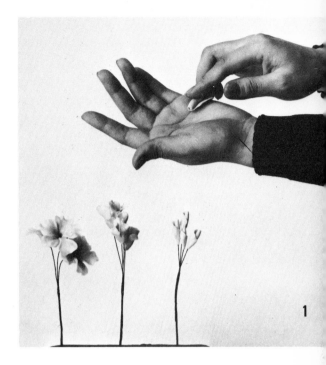

Leaf.

PRODUCTION AND DESIGN HINTS
When arranging these flowers, try to give the impression of a potted plant. They make attractive windowsill ornaments.

7. Refer to step 6 of the hydrangea (p. 40) for the method to use in combining buds and flowers into groups of five or six each.

8. For the main stem, use half of a standard length of number 18 wire. Add the groups of flowers and buds made in the preceding steps; the buds must be lower than the leaves (see Photograph on p. 66).

9. At this point, darken the colors of the flowers with appropriate shades of orange.

ASSEMBLING THE PARTS
10. Combine the flowers and leaves in the usual way. When you have added two or three leaves, reinforce with a piece of wrapped number 14 wire. Pad this stem with tissue paper and wrap with floral tape. Continue to add more leaves.

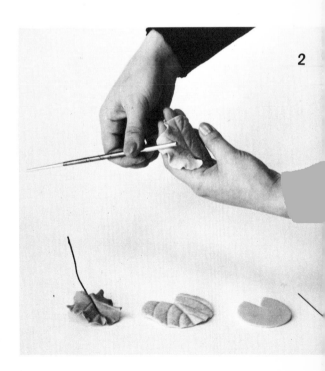

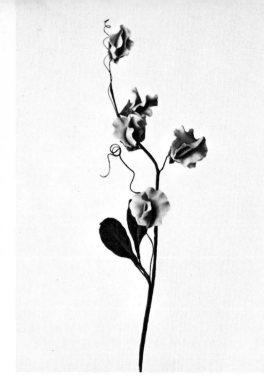

Sweetpeas

MATERIALS
Pando

Wire: numbers 26, 24, and 18

Oil paints: white, red (crimson lake), green-gray, and rose-gray

Painting oil

Floral tape: olive green

Adhesive

TOOLS
Wire-cutting scissors, small scissors, press, shaping rod, leaf mold I, ball-headed shaping rod, and brushes.

Center *(left)* **and petal** *(right)*.

FLOWERS

1. Cut standard lengths of number 24 wire into 4 equal parts; bend a small hook in the end of each piece. You will need five of these.

2. To make the center—actually a petal in the real flower—follow this procedure. Color some Pando red. Take a piece about the size of a marble and make a seed-shaped object— see the line drawing and Photograph 1—that is slightly thick on the side where the petals will later be attached. Dip the hooked end of a piece of wire in adhesive and insert it into the bottom of this center. You will need large and small centers. When they are finished, allow them to dry.

3. The petals, which are paler in color than the center, are double. Make the inner petal by forming a piece of Pando about the size of the end of your thumb into a round ball. Flatten this in the press, then bulge about two-thirds of the resulting sheet with the ball-headed shaping rod. With the ordinary shaping rod, put a ruffled edge on the unbulged part of the petal. At the base of the petal apply some adhesive. Then wrap the petal around the center and press it in place (Photograph 1).

4. The second petal is made in the same way, but it must be larger. When wrapping it in place, allow the outer petal to curl back from the center in the characteristic fashion. To make it easier to attach the calyx, trim away any excess Pando from the bottom of each flower.

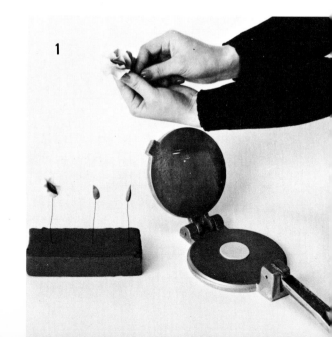

68

5. The half open flowers are made in the same way, though they are smaller. Furthermore the second petal is not allowed to curl back. It is wrapped close around the center like the first petal. When the flowers are finished, allow them all to dry.

6. Make the calyxes of balls of green Pando about the size of marbles. Cut the tops into five equal sections and shape each into a pointed projection (Photograph 2) with a toothpick.

7. When the calyxes are formed, highlight them with gray-green and rose-green paint. Apply a small amount of adhesive to the center of each and attach them to the undersides of the flowers.

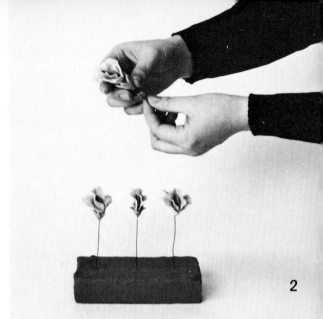

LEAVES

8. Make rounded, drop-shaped pellets of green Pando about as large as the end of your little finger and flatten them in the press. Adjust the shape to resemble the one in the line drawing. Taking care that the broad end is the outer tip of the leaf, press vein patterns with leaf mold I. Shape the pointed tip with your fingers. Make stems by cutting standard lengths of number 24 wire into 4 equal parts. Dip each in adhesive and attach it to a leaf. As you can see in Photograph 3, the leaves grow in sets of three.

9. Add shading and highlights to the leaves with green-gray and rose-gray paint.

10. Make the spiral tendrils of the sweet-peas by twisting number 26 wrapped wire around the handle of a paint brush and then adjusting the spring to a natural shape.

ASSEMBLING THE PARTS

11. The flowers are attached to the vine and the leaves are grouped at the bottom of the stalk.

12. Position a half-open flower at the tip of a piece of number 18 wire. Below this add three or four other flowers and still lower add the leaves. Fix these in place with floral tape. Add the spiral tendrils at places where they will look most attractive.

13. Finally use pink and crimson lake to highlight and shade the flowers.

Leaf.

PRODUCTION AND DESIGN HINTS

When adding the ruffled edges to the petals take care to make them look as soft as they do in the natural flowers. Arrange these flowers so that they make good use of the space surrounding them.

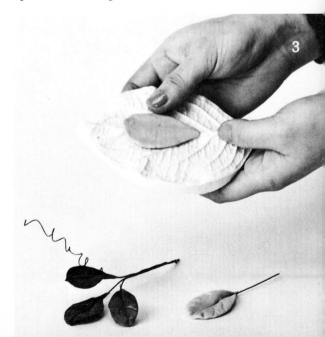

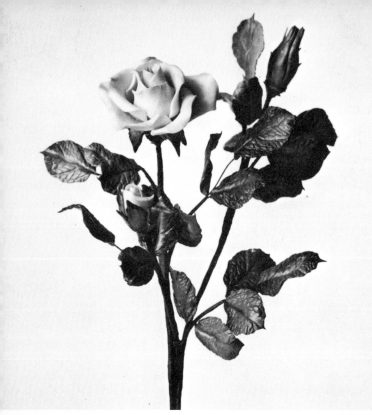

Roses

MATERIALS

Pando

Wire: numbers 22 and 16

Oil paints: green, red (crimson lake), and yellow-orange

Painting oil

Floral tape: olive green

Adhesive

TOOLS

Wire-cutting scissors, medium scissors, small scissors, press, leaf mold I, shaping rod, ball-headed rod, petal stand, and brushes.

FLOWERS

1. Bend a hook in the end of a piece of number 16 wire.

2. Make a flower center—conical in shape like the one in Photograph 1—from uncolored Pando. Dip the looped end of the piece of wire in adhesive and insert it in the bottom of the flower center. Allow this to dry thoroughly.

3. Divide some Pando into three batches; tint one dark red, one medium red, and one light red. From the dark red, take a piece about as big as the end of your little finger. Roll this into a small ball and flatten it in the press. Bulge and thin this round flat piece of Pando by pressing it against the palm of your hand with the small end of the ball-headed shaping rod. Further thin and curl the edge of this petal with the shaping rod. Make four or five of these. Attach them with adhesive around the center, which they must conceal completely.

4. Make similar, though slightly larger, petals of the medium-red Pando. After having bulged them with the large end of the ball-headed shaping rod, use your fingertips to roll the left side of each petal inward and the

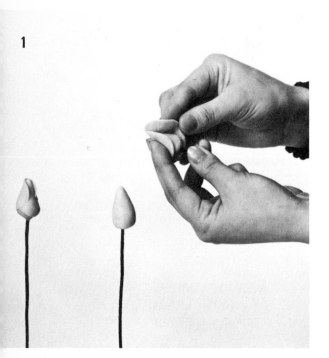

1

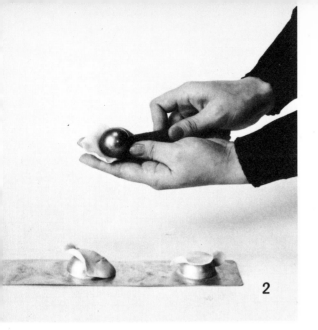

2

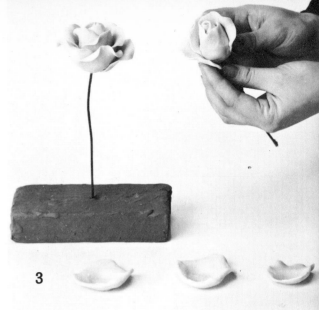

3

Inner petal.

Bulge the shaded zone with the ball-headed shaping rod.

right side outward. Bulge the center of each petal still further with the small end of the ball-headed shaping rod. Place them upside down on the petal stand to dry partly (Photograph 2). Make from four to six of these petals. Apply adhesive to the insides of their lower edges and place them around the darker inner petals on the flower center. The larger petals must overlap in a natural way (Photograph 3).

5. The largest and palest of the petals are made in the same way as the medium ones. After having bulged them with the ball-headed shaping rod, turn both the left and right sides outward. Make four or five of these petals and when they are about half dry, attach them to the undersides of the middle petals with adhesive.

6. Buds and calyxes for these roses are made like those for the rambler rose (p. 61), but their sizes must be adjusted to that of the larger rose.

LEAVES

7. These leaves are made like those for the rambler rose except that they are larger. They are combined in sets of three and five.

COLORING

8. Darken the centers of all the petals and lightly shade the outer petals with crimson lake.

ASSEMBLING THE PARTS

9. The parts are put together like those of the rambler rose.

PRODUCTION AND DESIGN HINTS

Roses are a welcome and attractive addition to any part of the home. Since they are heavy flowers, it is wise to arrange them in low masses to take advantage of that weight.

71

Mexican Poppies

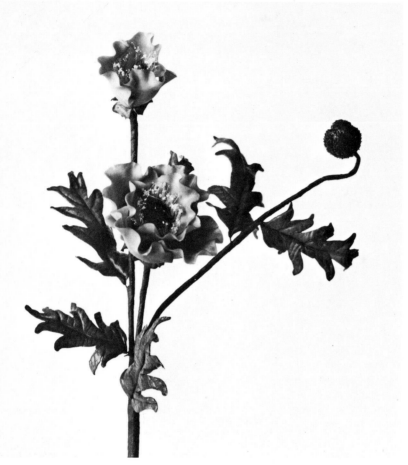

MATERIALS

 Pando

 Wire: numbers 18 and 14

 Oil paints: orange, green, and (crimson lake)

 Painting oil

 Floral tape: brown

 Tissue paper

 Strands from hemp rope

 Poppy seeds

TOOLS

 Wire-cutting scissors, medium scissors, small scissors, press, shaping rod, ball-headed shaping rod, leaf mold I, petal stand, and brushes.

Petal.

Bulge the shaded zone with the ball-headed shaping rod.

72

FLOWERS

1. Wrap a length of number 14 (30 centimeters) wire in floral tape and bend a small hook in one end. You will need two of these.

2. Make one large and one small flower center in the following way. Color some Pando pale green. With a piece of this material about as big as the end of your thumb, make a flattish, round cake shape (Photograph 1, lower right). Dip the end of a piece of looped wire in adhesive and insert this into the flower center from the bottom. With another piece of number 14 wire, make a pattern of indentations over the entire upper surface of the flower center. Make a small flower center in the same way. Allow these to dry.

3. For the stamens cut hemp strands into pieces about 12 centimeters long. Fold them in half. Attach them by wiring them to the wire stalk under the flower center (Photograph 1). To hold them in place, apply some adhesive around the periphery of the flower center and press the hemp strands into it. Pad the wire stalk with tissue paper and wrap again with floral tape (Photograph 1).

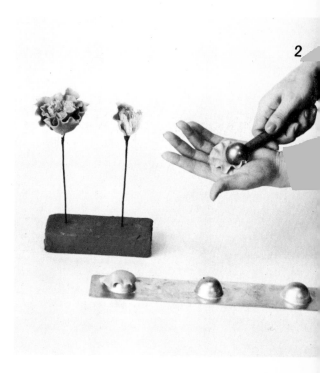

4. For the petals, color some Pando orange. Make balls of this material about as large as the end of your thumb. Flatten these in the press. Then, using the large end of the ball-headed shaping rod, bulge the lower two-thirds of each petal. Next with the shaping rod, make a ruffled fringe around the upper edge of each petal (see line drawing and the directions for sweetpea petals on p. 68). Next press the center of each petal with the small end of the ball-headed shaping rod to bulge it further. Place the petals on a petal stand (Photograph 2) to dry partly.

5. When the petals are half dry, put adhesive on the inner sides of their lower edges. Attach them around the flower center. For a fully open poppy make seven petals. The three placed on the inside must be slightly smaller than the four outer ones.

6. Four petals are sufficient for a half-open poppy.

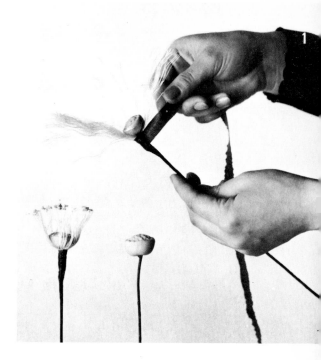

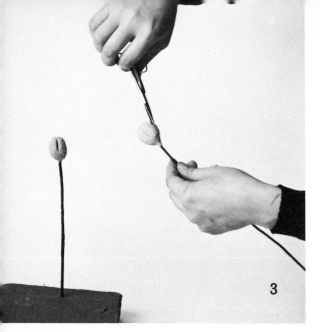

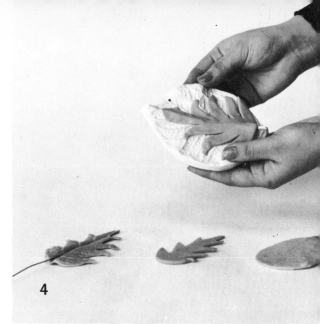

3

4

7. Make the bud from a thick, longish oval of green Pando. With large scissors make an incision that cuts the top part of this oval in two equal parts. Bend a small loop in the end of a piece of number 18 wire. Dip the looped end in adhesive and insert it from the bottom of the bud. Lightly press the two parts of the bud together again. Holding small scissors as shown in Photograph 3, cut small thornlike projections over the entire surface of the bud.

8. Make the calyxes for the flowers in very much the same manner, including the cutting of small thorns over the entire surface. But in the case of the calyxes, use the shaping rod to thin and round the two sections. Put a small amount of adhesive in the center of each calyx and insert the wire stem of a flower in the middle.

LEAVES

9. From green Pando make tapering drop-shaped pellets about 5 or 6 centimeters long. Flatten these in a press and serrate the edges so that they resemble the line drawing. Press these sheets of Pando on leaf mold I to make vein patterns. Attach half a length of number 18 wire and allow the leaves to dry.

COLORING

10. Darken the edges of the petals with shaded orange and highlight and shade the center with green and crimson lake. Soften

Leaf.

and deepen the colors of the calyxes and leaves with green, crimson lake, and brown.

ASSEMBLING THE PARTS

11. Use two or three leaves with each flower and bud. Combine them with wire and tape in the usual fashion and shape the branches to look natural.

PRODUCTION AND DESIGN HINTS

The stems of poppies are gently curved. This characteristic is especially important in capturing the feeling of the blossoms and buds.

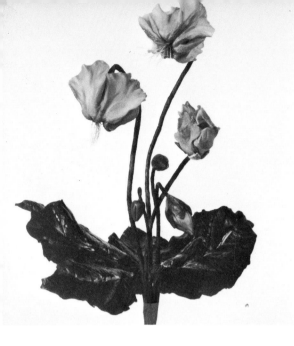

pellet into five equal parts. Use the shaping rod to form five long petals. Round the ends of the petals (see line drawing).

3. Dip the hooked end of the wire in adhesive. Insert the wire in the center of the set of petals from the top. Fold five strands of hemp in half, dip the folded ends in adhesive, and insert the bunch into the center of the set of petals. Using you fingertips, fold the petals back to give the characteristic appearance of cyclamen blossom. Allow the flower to dry (Photograph 1).

4. For the half-open flowers, use a piece of pink Pando about the size of the end of your little finger. Following the procedure

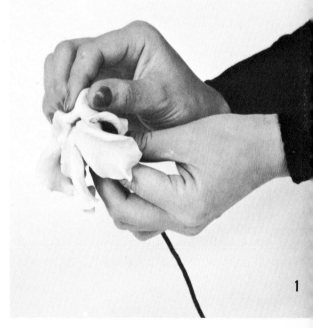

1

Cyclamen

MATERIALS
Pando
Wire: number 18
Oil paints: white, red (crimson lake), rose-gray, green-gray, and green
Painting oil
Floral tape: olive green
Tissue paper
Strands from hemp rope
Adhesive

TOOLS
Wire-cutting scissors, medium scissors, press, shaping rod, leaf mold I, and brushes.

FLOWERS
1. Pad a standard length of number 18 wire with tissue paper and wrap this with floral tape. Bend a small hook in one end of the wire.

2. For the fully open blossom, color the Pando pink with a mixture of red and white oil paints. Shape a piece of this Pando about the size of the end of your thumb into a drop-shape pellet. Cut the thick end of the

Petals.

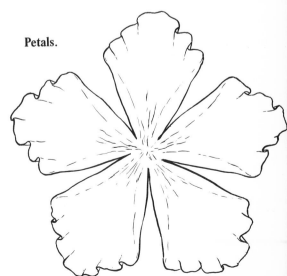

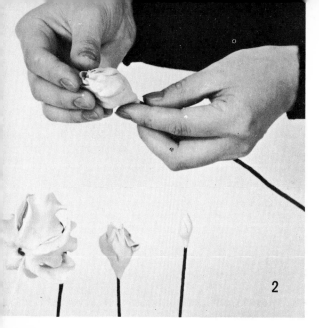

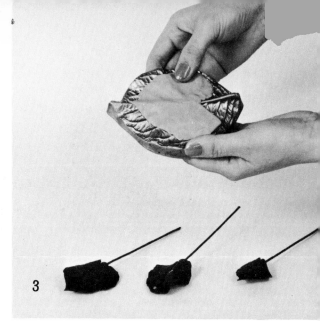

2

3

used in making the fully open flowers, at the final stages, lightly twist the petals and bring them together to the center (Photograph 2).

5. Use about two-thirds as much pink Pando for the buds as you used for the half-open flowers. Make a long, slender, drop-shaped pellet. Cut the thick end into five equal parts and insert a piece of padded and wrapped wire in the center. Lightly twist the ends of the petals and allow the bud to dry (right in Photograph 2).

6. For the calyxes, color some Pando green-gray. For each calyx take a piece of Pando about the size of a large pea. Roll it into a long, slender, drop-shaped pellet. Cut the thick end of the pellet into five equal parts. Lightly shape each of the five sections with shaping rod. Put some adhesive in the center of the inside of the calyx. Then insert the wire stem of one of the flowers or buds.

7. Add color highlights to the flowers and buds with crimson lake and white and to the calyxes with green-gray and rose-gray.

LEAVES

8. Color some Pando dark green and make cylinders of it. Flatten them in the press. Make a triangular cut in the base of each leaf. Press them against leaf mold I to make vein patterns (Photograph 3). Use your fingertips to shape each into a heart (see the line drawing).

9. Wrap some number 18 wire and cut standard lengths in half. Attach each piece to a leaf with some adhesive. Dry the leaves throughly then add color highlights with green and crimson lake. Touch up the main veins of each leaf with white paint.

ASSEMBLING THE PARTS

10. Combine two or three leaves with each flower. The small leaves are nearer the top of each stalk. Bend the stems at the bases of the flowers in the way that is characteristic of the cyclamen.

PRODUCTION AND DESIGN HINTS

Vary the positions and shapes of the petals to create a feeling of movement. The buds and half-open flowers must be partly concealed low among the leaves.

Leaf.

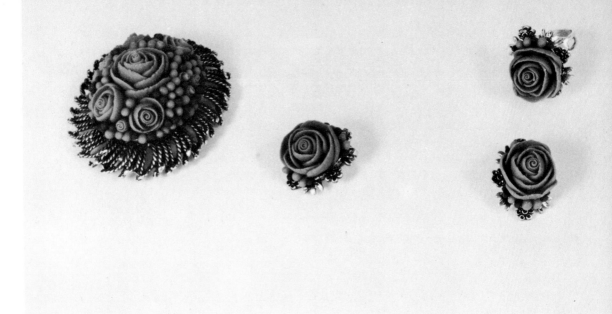

Brooch and Earring Set

MATERIALS
Pando
Wire: number 22
Oil paints: colors of your choice
Adhesive
Brooch mounting
Pair of earring mountings

TOOLS
Wire-cutting scissors, medium scissors, and tweezers.

MAKING THE FLOWERS

1. Cut as many 5-centimeter lengths of number 22 wire as you need for the number of flowers in the set. Color Pando the colors of your choice.

2. First make the flower center. Taking a piece of pando about the size of a green pea, lightly flatten it against the palm of your left a hand until it is about 1 centimeter wide and 3 centimeters long. Roll this from the top and insert a piece of wire into it (Photograph 1). Use one flower center of this kind for each half-open and each fully open blossom.

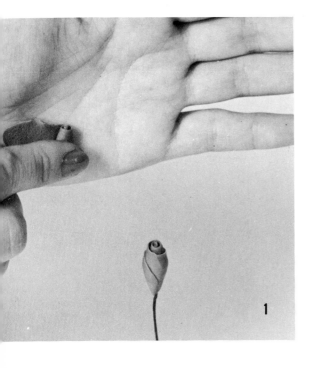

1

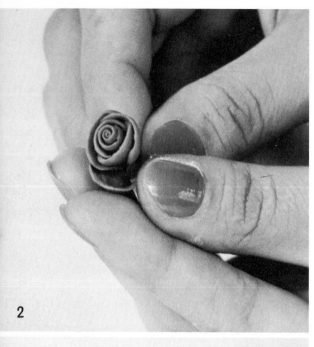

2

3. To make the fully open flowers, take a piece of Pando somewhat smaller than the one used in making the center, flatten the Pando into a strip about 1 centimeter wide. Apply adhesive to this strip and wrap it around the center (Photograph 2). Make about eight of these petals and attach them to the center. Adjust the shapes and dry the flower thoroughly. When it is dry, pull out the piece of wire that was used only as a base on which to build the flower (Photograph 3, left).

4. The half-open flowers are made just like the fully open ones except that only three or four petals are attached to the center (second from the left in Photograph 3).

5. Buds are made exactly like the half-open flowers, though they are smaller and do not use the wire.

6. Role some colored Pando into small balls about as big as match heads and allow them to dry (right in Photograph 3).

3

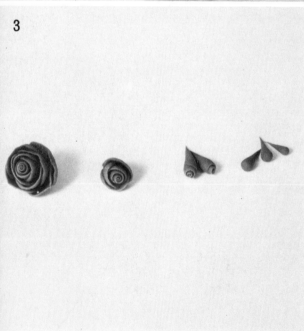

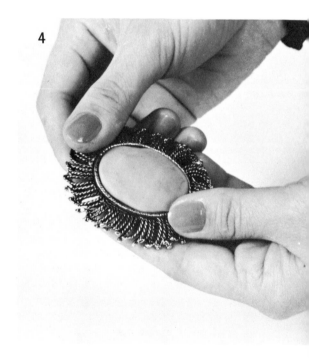

4

78

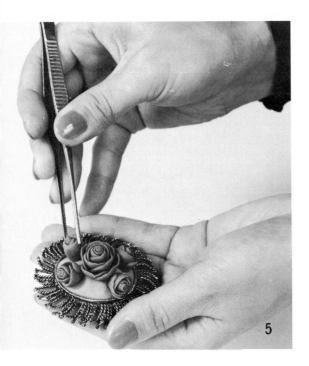

5

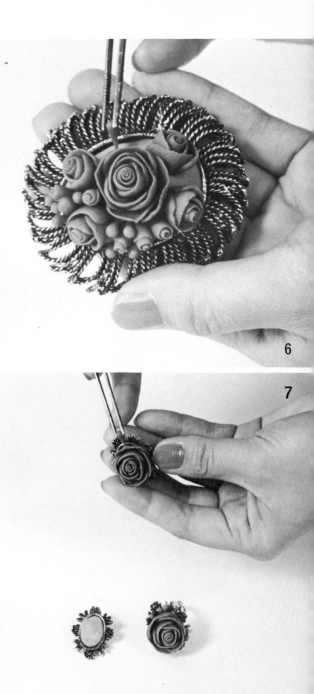

6

7

ASSEMBLING THE PARTS

7. Coat the inside of the brooch mounting with adhesive and apply an even layer of Pando the same color as the flowers you have made for the set (Photograph 4).

8. Coating the bottom of each flower with adhesive, arrange fully open and half-open flowers and buds attractively in the mounting (Photograph 5). Fill in the spaces among the flowers with the match-head balls of Pando. Allow the brooch to dry (Photograph 6).

9. The earrings are made in the same way (Photograph 7).

PRODUCTION AND DESIGN HINTS

Use two colors to prevent the brooch and earrings from looking monotonous. To create a feeling of stability, place the fully open flowers in the center and surround them with half-open blossoms and buds.

Although some of my readers may have found Luna Flora difficult, others probably learned to their surprise that they are actually very easy. No matter what your reaction to the difficulty of these flowers, however, I hope that you have enjoyed trying your hands at this new version of a traditional craft. The thing that makes creative activity meaningful is the opportunity it gives us to return to the guileless, imaginative freedom of our childhood. In making Luna Flora, try to recapture the spirit you probably had when, as a child, you made elaborate castles and cities in the sand pile.

Other applications of Pando: figurine made from a bottle *(left)* **and a chicken wall plaque modeled on Central American folkcraft ornaments.**

As mechanization encroaches on almost all phases of everyday living, one of the few ways we have left to recapture our own fundamental human warmth and value is creative endeavor. Luna Flora and the new material Pando bring creative work within the reach of everyone who will make the required effort. This is their major importance.

It is our responsibility to exert our best efforts in study and development to prevent Luna Flora from remaining no more than a folkcraft. If we put our ingenuity to work, we can extend the field to include much of the artistic value found in art flowers, ceramics, and sculpture. But we must not allow Luna Flora to be limited to realistic representations of nature. Instead, using our new material, we must advance into new fields of artistic endeavor. I intend to take every opportunity to develop new and more interesting Luna Flora creations, and I hope that all of my readers will join me in this exciting and important study.

For further information about the production and procurement of Pando and all the equipment used in making Luna Flora please write to

The Japan Publications Trading Company, Ltd.,

who will be happy to explain ordering and mailing procedures.